Beginner's Guide to
Bead Netting

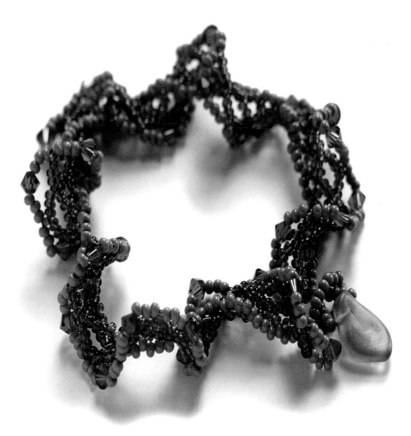

Dedication

To my family, and especially my husband for his support.

*Wax egg decorated with beads.
Owned by the author.*

Beginner's Guide to
Bead Netting
Madeleine Rollason

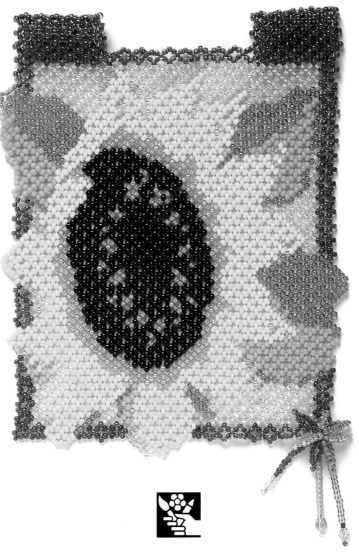

SEARCH PRESS

First published in Great Britain 2007

Search Press Limited
Wellwood, North Farm Road,
Tunbridge Wells, Kent TN2 3DR

Text and beaded designs copyright
© Madeleine Rollason 2007

Photographs by Steve Crispe, Search Press Studios; and
Storm Photography.

Photographs and design copyright
© Search Press Ltd. 2007

ISBN-10: 1-84448-110-7
ISBN-13: 978-1-84448-110-1

The Publishers and author can accept no responsibility for
any consequences arising from the information, advice or
instructions given in this publication.

Readers are permitted to reproduce any of the items in
this book for their personal use, or for the purposes of
selling for charity, free of charge and without the prior
permission of the Publishers. Any use of the items for
commercial purposes is not permitted without the prior
permission of the Publishers.

Suppliers
If you have difficulty in obtaining any of the materials and
equipment mentioned in this book, then please visit the
Search Press website for details of suppliers:
www.searchpress.com

Alternatively, you can visit the author's website:
www.maddiesbeadshop.co.uk
to obtain materials and equipment via her own
mail-order service.

Publishers' note

All the step-by-step photographs in this book feature
the author, Madeleine Rollason, demonstrating her
beadwork techniques; no models have been used in the
step-by-step photography.

Acknowledgements
I would like to thank the Saraguro beaders
and Dr Linda Belote for their inspiration,
encouragement and support, and for the
generous sharing of their work.

Thanks also to Carole Diane Catlin who helped
test out the patterns in the book. These were
designed and created by me using Beadscape
beading software, and I would like to thank the
creators of Beadscape for making the design
process so much easier.

I would also like to thank the Toll House
Beaders who did a brilliant job of testing
out some of these projects at the weekend
workshop in Lancashire, November 2004.
Thank you ladies, I had a great time.

The Toll House Beaders
*Back row, left to right: Lesley Dudson, Charmain
Gallagher, Myrna Carr, Lynda Howard and
Valerie Robinson. Seated, left to right:
Barbara Robinson, Rohana Stoddart and Val Trimby.*

*The bracelet on page 1 is the same as the project on
page 54, made with different-coloured beads. The
instructions for the wallhanging on page 3 are provided
on pages 64–67, and those for the green necklace
opposite are given on pages 44 and 45. The bottle on
page 6 (bottom left) is a Russian bead-crocheted bottle
cover, dated 1911. Owned by author.*

Contents

Projects

Introduction

I was really pleased when Search Press agreed to my writing this book as so much had happened since my last one. I had travelled widely, and some of the designs in this book were inspired by the places I visited.

So why write a book on bead netting? Having made several beaded pieces using brick stitch, peyote stitch and various other techniques, I decided to explore bead netting. I had made necklaces using bead netting and wondered whether it could be adapted and used for other projects. I loved its open, fluid style and was impressed by how quickly a project could be made using this technique (I'm not known for my patience!). It is for these reasons that I wanted to share my discovery and my enthusiasm for this often neglected beading technique.

I scoured the internet, bric-a-brac, second-hand and antique shops for inspiration and found some lovely ideas and pieces. This was the beginning of my collection of netted beadwork; the only problem was, where to put it all! It is incredible how many beautiful and varied items can be found; on pages 8–17 are just a few examples of my recent finds, each one representing a particular culture or style.

I hope this book will be enjoyed by both beginners and experienced beaders. I have begun by describing all the

equipment, materials and basic techniques you need to complete the projects, and then moved from relatively simple projects to more advanced ones. I hope that the designs offer something for everyone, from earrings and bracelets to wallhangings and evening bags. Some of these are shown in the photograph opposite. I have listed all the materials and quantities that you will need for each project, though you can of course substitute any of the materials with those of your own choice to create something more individual and personal to you. My only comment would be that if you use different-sized beads, the quantity of beads you need and the size of the finished piece will differ from that shown in the book.

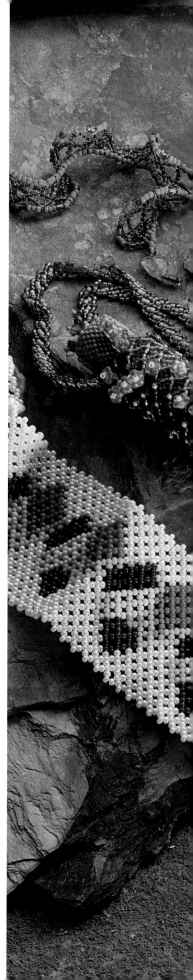

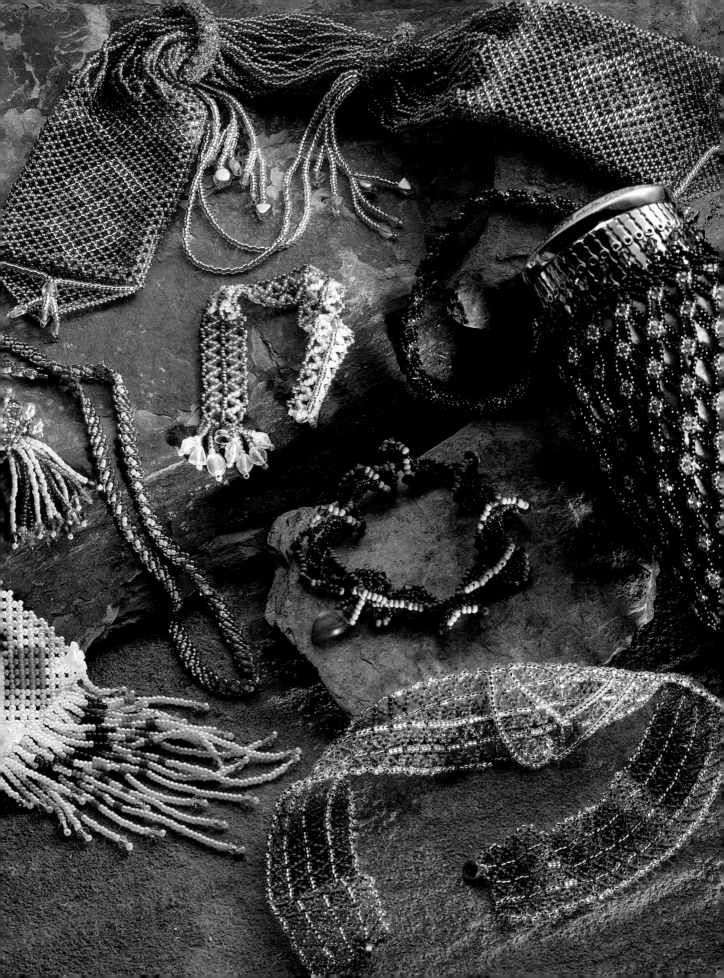

Saraguro beadwork

I am in awe of the beading skills of the Saraguro people of Ecuador. Their beadwork has now gained well-deserved worldwide recognition within the beading community. I began buying some of their beadwork through Dr Linda Belote, an anthropologist who has been associated with the Saraguro since the 1960s. This was the beginning of my fascination with bead netting.

The Saraguro beaders have a very distinct bead netting style which uses a looped technique. A beautiful, fluid effect is created, resembling a piece of crochet.

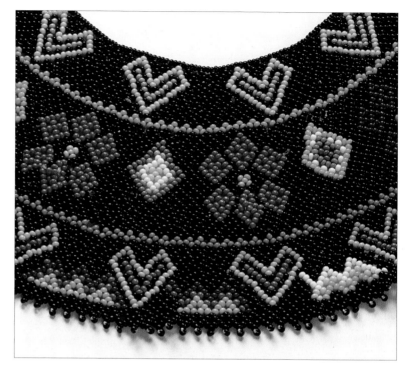

Details of a pretty patterned collar from Ecuador.

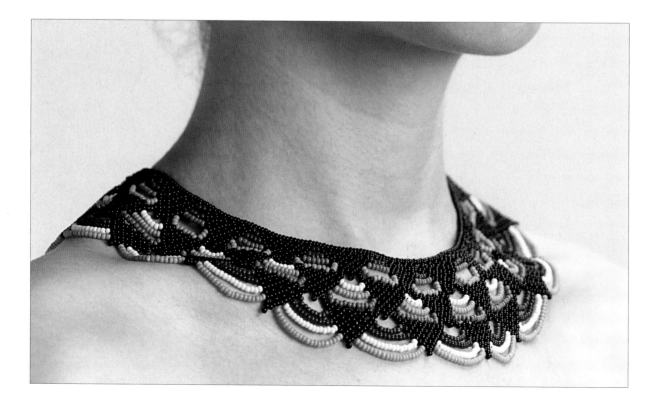

These beautiful collars are worn daily by the Saraguro people, and for this reason the beads they prefer to use are those without special finishes which fare better in the Ecuadorian climate. Beads such as size 10 Czech opaque are very popular.

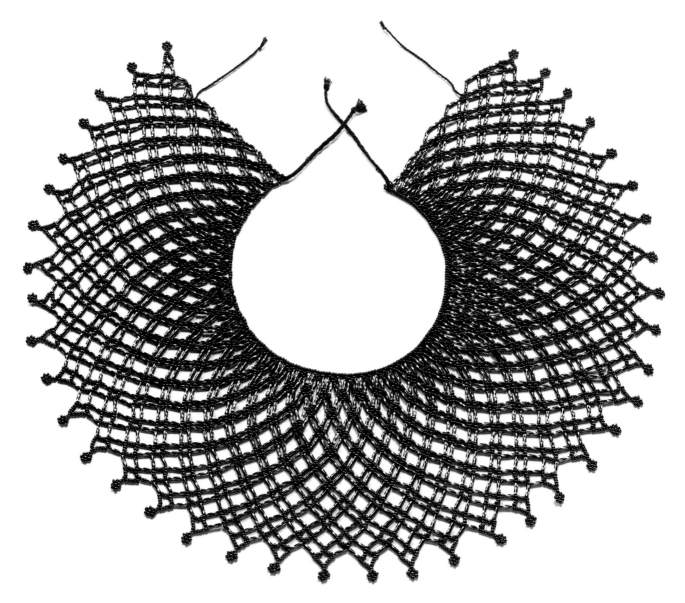

The Paralelos collar, using twisted bugle beads and Czech seed beads.

(Left) A small looped net collar from Ecuador.

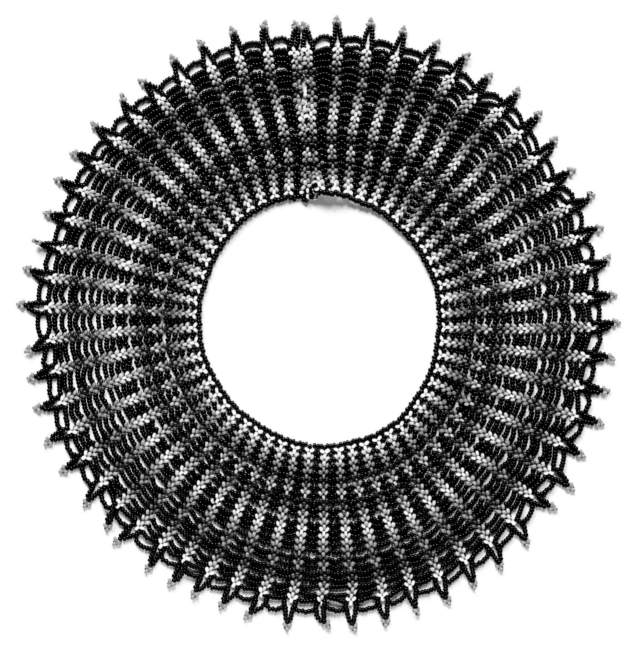

A beautiful netted necklace, increased from the centre outwards by adding progressively more black beads between the coloured ones.

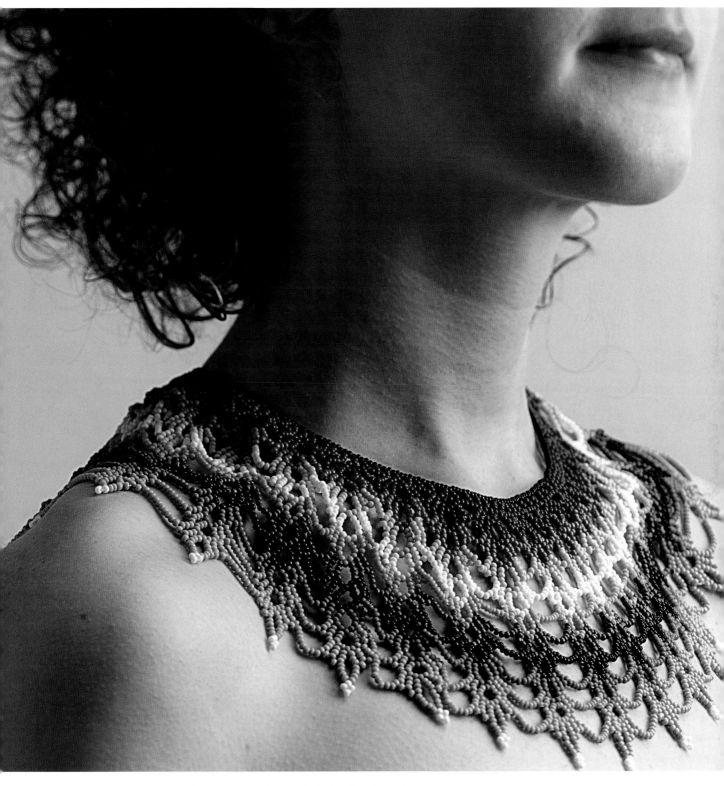

*I don't know the name of this piece, or who made it, but it is based on a
design that originated in the 1960s beadwork of the Saraguro people.*

Asian beadwork

Asia, in particular India and Pakistan, has a long and rich history of producing a variety of crafts, including beadwork. Bead netting is very popular, and once completed it is usually sewn on to cloth and used to decorate a variety of everyday objects, including fans and even face masks for elephants!

India also has a well-established glass-bead making industry, and although these beads may not have the uniformity of other types of beads, they do come in a wonderful range of rich and vibrant colours. Just take a look at the beautiful colours in the wallhanging below. It comes from the Gujarat region of India and would have hung above the doorway of a farmhouse.

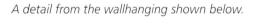

A detail from the wallhanging shown below.

A wallhanging from the Gujarat region of India, circa 1950s. Owned by the author.

In contrast to the wallhanging, the beadwork shown on this page uses Czech seed beads and is from a later period, probably created for the tourist industry.

This unusual children's hat is decorated with coral beads. The technique used is possibly beaded crochet. It originates from Asia, circa mid to late twentieth century. Owned by the author.

The beaded crochet rope necklace shown on the left originates from India or Pakistan, circa mid to late twentieth century. Owned by the author.

A brief history of beadwork

Beads have been around for thousands of years. They are made from a variety of materials such as shell, wood, bone and stone, carved and shaped by hand, and in their most basic form strung on animal sinew or rope. Bead netting has been found from as early as Egyptian times, with bead-netted shrouds found covering the sarcophagi; such a shroud was even discovered in Tutankhamen's tomb. Beads have been used to fulfil various needs, from simple adornment and jewellery to displays of personal status and wealth. Within some Native American tribes, beads were used as currency as well as being used in clothing and everyday objects.

Nowadays the most popular beads for bead weaving and general beadwork are made of glass and come from the Czech Republic, Japan and India. Beads from Japan are the most expensive and are generally considered to be the finest.

Although the focus of this book is bead netting, I think it important to acknowledge the variety of techniques used to create beaded objects, and hopefully inspire readers to expand their beading skills and try out these different methods.

A pair of pipes believed to be Native American (although the lower pipe could be South African, possibly made by the Ndebele people). Both pipes are probably early twentieth century, made using Czech beads wrapped around the pipe stem. Owned by the author.

Beads and beadwork have played an important role within the art and crafts of most cultures, from simple bead stringing to elaborate and beautiful pieces of art. European beadwork has a long and varied history; from as early as the seventeenth century, women created beautiful embroidery, knitting and crochet using beads to display their needlework and craft skills.

English glass-bead embroidered footstool, dated 1850s. Owned by the author.

The embroidered stumpwork on this Victorian cushion, dated 1880s, uses large Czech glass beads. Owned by the author.

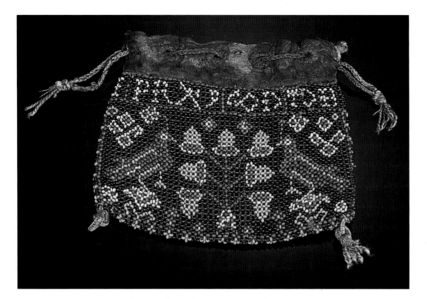

This English seventeenth-century bag consists of netted beadwork made with glass beads sewn to a lining, inscribed 'I pray God to be my guide'. Dated 1634. Reproduced with kind permission of the Victoria and Albert Museum.

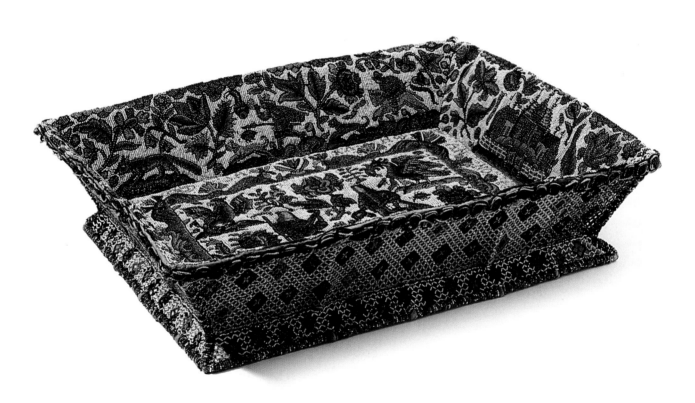

Seventeenth-century basket made with glass beads netted in wire and sewn on to silk. It is inscribed 'Sarah Gurnall', possibly the maker or recipient, and dated 1659. Reproduced with kind permission of the Victoria and Albert Museum.

In the early nineteenth century knitted purses were very popular in Europe, particularly in Holland and England. Ladies would buy bead-knitting kits; these would be made up of balls of wool that had been pre-strung with beads by children, very often from Bohemia (now known as the Czech Republic), who received a pittance for their work. Various patterns were used for these kits, including cross stitch and embroidery patterns.

Interest in the craft of beading saw a dramatic decline in Europe, and particularly in England, in the twentieth century, however in the 1990s a resurgence in the craft of beading began. Hopefully this trend will continue for some time to come.

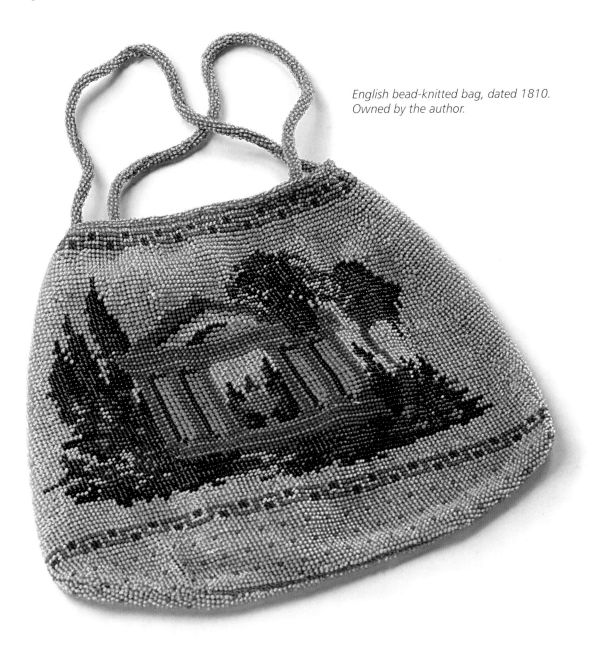

English bead-knitted bag, dated 1810. Owned by the author.

Materials

The main requirement for any kind of bead weaving is, of course, beads. One of the great things about the craft of beadwork is that materials are readily available and affordable; most embroidery and craft shops now stock various types of beads that can be used in a wide range of projects. Excellent sources of beads are charity and second-hand shops that may have old necklaces and bracelets that can be taken apart and reused, and you can also reuse the clasps and catches.

It is impossible to cover every type of bead available in this book, so I have focused on the most common ones, and those used for the projects on pages 54 onwards.

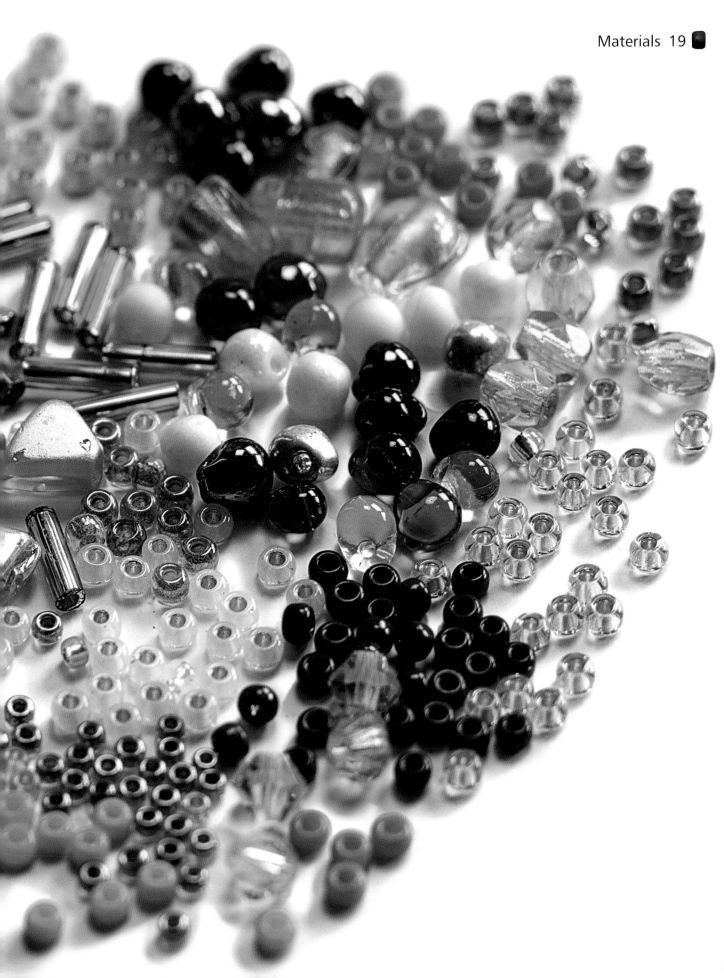

Seed beads

These are the most popular and widely used type of bead in bead weaving. The most important thing to remember when undertaking any kind of beadwork is to use the right bead for the job; for example Czech seed beads are shaped something like a doughnut and are therefore better suited to bead stringing and embroidery. Japanese beads have a more uniform shape, which means they fit together neatly and can be used for finer, more intricate work where a smooth and even finish is required. Japanese seed beads can be divided into two main categories: ordinary seed beads and the more precise and cylindrical Delica or antique beads. Delica beads are generally considered to be the finest – at nearly twice the price of ordinary Japanese beads they are usually used only for the finest beadwork.

The size of bead is also extremely important to the finished piece, as inevitably the work will be larger or smaller depending on bead size. Bead size is measured in terms of how many beads sitting side by side in a row there are to an inch (2.5cm). For example, size 11 beads means there are approximately eleven beads to an inch, size 15 means there are fifteen to the inch, and so on, so the larger the size the smaller the bead (although this can vary depending on the finish). The most common sizes used in beadwork are Czech size 10 beads and Japanese sizes 8, 11, 12, and 15; these are the beads mainly used in this book, and in particular those manufactured by Miyuki Shoji Co.

I have included five one-inch (2.5cm) square swatches below, each woven using different-sized beads, to give you some idea as to how many beads of a particular size and/or type there are to a square inch, however bear in mind these measurements are a rough guide only.

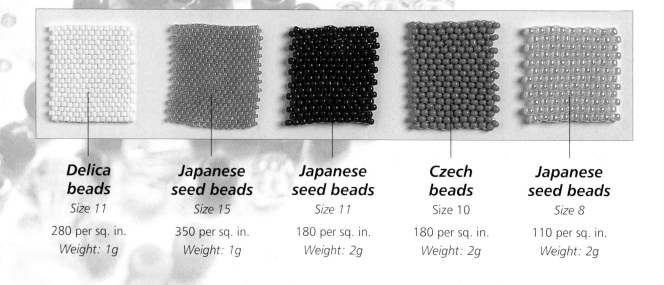

Delica beads	Japanese seed beads	Japanese seed beads	Czech beads	Japanese seed beads
Size 11	*Size 15*	*Size 11*	*Size 10*	*Size 8*
280 per sq. in.	350 per sq. in.	180 per sq. in.	180 per sq. in.	110 per sq. in.
Weight: 1g	*Weight: 1g*	*Weight: 2g*	*Weight: 2g*	*Weight: 2g*

Bugle beads

These are long, cylindrical beads available in a variety of colours, finishes and sizes. They are sized in millimetres with the most common sizes being 2, 3 and 5mm. Care should be taken when using bugle beads as their edges can be quite sharp and may cut your thread. I tend to use them in between seed beads, which helps protect the thread.

Round beads

Round beads can be made from plastic, glass, wood and semi-precious stones. They are sized in millimetres, most commonly from sizes 2mm to 10mm, although they are available in larger sizes.

Shaped beads

There is a huge range of shaped beads on the market, including triangles, squares and hexagons as well as flower-, heart- and leaf-shaped beads. These beads can be used to produce interesting and varied effects within any beaded project.

Faceted beads

Crystals are a good example of faceted beads; these beads can have a variety of finishes, from shimmering to matt. I use crystals a great deal in my projects to add texture and very often to add fringing. Faceted beads are useful as accent or feature beads. They are usually sized between 2mm and 10mm.

Needles

Strictly speaking, any needle that can pass through the hole of a bead can be used, however I would recommend using a purpose-made beading needle. Beading needles are thinner and have a smaller eye than regular needles, ensuring that they will pass easily through most beads. For general beadwork I use size 10 beading needles and keep a good stock of them to hand. If working with smaller beads, such as size 15 seed beads, then a thinner needle is recommended. I use a size 13 needle for such beads. Size 15 needles are available, but they are not easy to work with and tend to snap very easily.

From left to right: big-eyed needle; collapsible-eye needle; bead loom needle; size 10 general beading needle; size 13 general beading needle; size 12 short general beading needle.

Types of beading needle

There are special beading needles designed for specific tasks, for example big-eyed needles are very useful if you have difficulty threading needles, as the whole needle has a split down the middle and is, effectively, the eye. They are also useful when using very small beads as they are quite thin and pass through beads easily. Twisted collapsible-eye needles have a large, round eye which again helps in threading the needle as the eye is easy to see and collapses in on itself when passed through a bead.

Another useful beading needle is that used for loomed beadwork. It is longer than most types of needle, making it possible to pass through several beads at once on a beading loom. Size 12 short needles are useful when weaving in with very little thread or if working on a small project, as they allow you to get into tight corners!

Threads

Any kind of stringing material can be used when working with beads, although I would recommend using a strong, lightly waxed thread that contains nylon. The most commonly used thread for beadwork is called Nymo, initially used in the tailoring industry because of its strength. Nymo comes in various sizes ranging in thickness from size 00 to FF with 00 being the thinnest. For general beadwork sizes B to D should be used, the choice of thread ultimately depending on the size of the bead hole.

Nymo is available in a variety of colours. If I am unable to obtain a thread in a colour that complements the beads I am using, I use white as this can later be coloured with a felt-tip pen to match the beads where it shows through the work.

Similar to Nymo is Silamide, a thread which again is used in the tailoring industry. It is a twisted, waxed-nylon thread and can be used in the same way as Nymo.

In addition to thread, nylon-coated wire is useful when stringing beads for a necklace or when a firmer finish is required. Wire is available on reels in various sizes.

Preparing your thread

Although not essential, it is useful to wax your thread before using it as this helps prevent knots, frayed and tangled thread. There are products you can buy, however beeswax works just as well. If beeswax is unavailable, I have used lip balm as a substitute. Prepare your thread by passing it across the wax two or three times.

Findings

This is a general term used for necklace clasps, brooch backs, earring wires, earring studs and jump rings. These are used to finish off pieces of jewellery and to secure and fasten projects. There is a huge variety available and they can be sourced from most craft shops and jewellers.

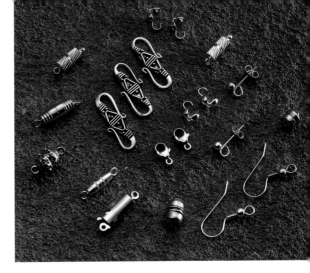

Other useful equipment

A good pair of embroidery scissors and a pair of general-purpose scissors are essential. Other useful items are: pliers to close jump rings and fastenings, a tape measure, sticky tape to keep loose threads in place and tweezers for handling those tiny beads! Some form of beading mat, either a piece of velvet or any material with a nap, is useful (though not essential) to stop the loose beads from rolling around while you are working. Also useful are small craft pots or saucers to store your beads in. Some beaders use old photographic film containers to hold their beads, though these are becoming scarce since photography went digital. I also like to have some clear nail varnish available as this helps to seal knots within the beadwork, making it secure. Another item you can buy is a 'thread zapper' that burns off and seals the ends of your thread; very useful but definitely not essential.

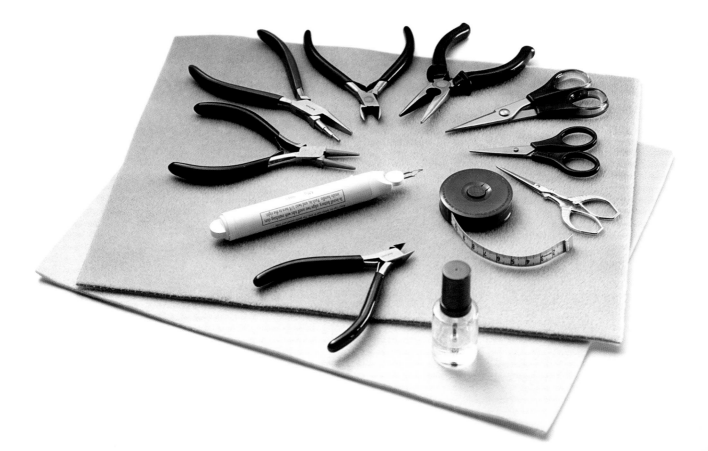

Basic beading techniques

I thought it essential not only to focus on bead netting, but also to demonstrate other basic beading techniques as some of these are used in combination with bead netting in the projects. Once you have mastered these basic techniques you will be able to undertake a wider variety of beadwork projects.

I have used Japanese size 11 seed beads for all of the following demonstrations.

Preparing the thread

Before beading, prepare your thread by pulling it through a beeswax block twice. This conditions the thread and prevents it from fraying and tangling.

Picking up beads

One of the trickiest things for novice beaders is picking up beads; here I have demonstrated a couple of steps to help make this easier.

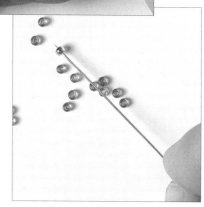

1. Hold the needle at the end and rest it on the side of the bead. Keep the needle as close to the work surface as possible.

2. Press down gently on the side of the bead and flick it on to the needle.

Peyote stitch

Also known as twill or gourd stitch, peyote stitch is flexible, quick, and one of the most popular beading techniques. It is widely associated with Native American beadwork, although it is only one of an extensive array of beading techniques that the Native Americans used.

I have used basic even-count peyote stitch for the projects in this book, therefore this is the technique I have demonstrated here. Odd-count peyote is not used very often unless you need to centre a piece of beadwork, for example when the work needs to come to a point or when increasing or decreasing. More advanced forms include tubular and circular peyote stitch. I have not covered these techniques here as they are not required for the projects.

Peyote stitch always begins by threading on the first two rows. For example, if there are four beads in a row, start with eight beads for the first two rows, and then four beads for the third row onwards.

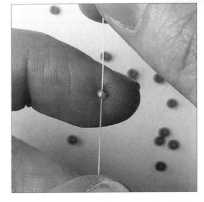

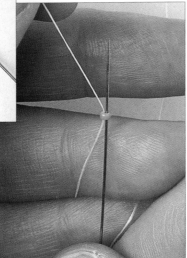

1. Thread your needle with 90cm (36in) of thread. Pick up the first bead and slide it to about 15cm (6in) from the end of the thread. This is the stopper bead. The tail thread can be woven into your work later.

2. Take the needle round and back through the bead to form a loop. This bead is known as the stopper bead, as it prevents the other beads from rolling off the end of the thread.

3. Keep the thread taut and pull it tight to secure the bead.

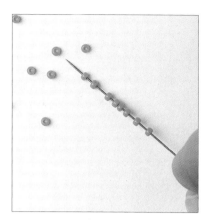

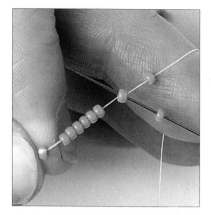

Remember...

When working peyote stitch, always begin by threading on enough beads for the first two rows.

4. Pick up an even number of beads – as many as you require. For this demonstration, I have used eight. Slide them down the thread to the stopper bead.

5. Steady the beads by clasping the thread tightly between your fingers and pulling it taut. Pick up another bead with your needle and pass it back through the second-to-last bead you threaded on (bead 7).

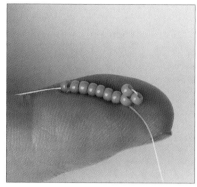

6. Pull the thread tight so that the new bead (bead 9) is sitting on top of bead 8. This is the beginning of row three.

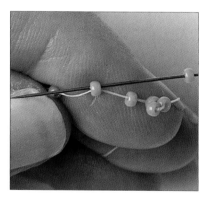

7. Pick up another bead and, missing a bead out, pass the needle through the fifth of the eight beads you threaded on at the start (bead 5).

8. Pull the thread tight and continue to the end of the row, passing the needle through every other bead.

Tip

Make sure you keep your work still and always work backwards and forwards across it. Never turn your work. Keep your eye on the stopper bead and use it to mark your position.

9. Work back the other way across your work to create row four. Begin by picking up another bead and passing the needle through the first 'up' bead in row three.

10. Continue working across, effectively filling in the gaps between the 'up' beads.

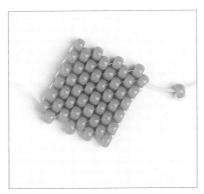

Twelve rows of peyote stitch.

Decreasing and finishing off

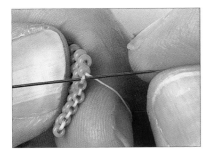

11. To decrease at the start of a row, first pass the needle under the thread joining the previous two rows, in other words the last two beads on the edge of your work.

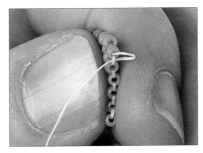

12. Pull the thread through.

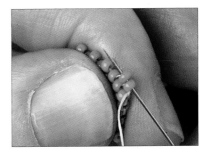

13. Pass the needle back through the first bead in each of the previous two rows. You have effectively missed out the bead at the start of the current row, and therefore decreased by one bead.

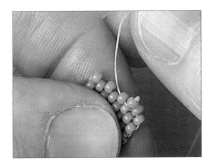

14. Continue to the end of the row, adding in beads in the normal way.

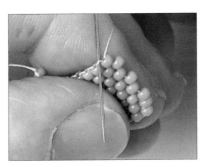

15. To decrease at the end of the row, pass the needle under the thread joining the last two beads on the edge of your work and pull the thread tight.

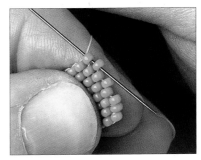

16. Pass the needle through the first beads of the previous two rows (see step 13), thereby decreasing your work by one bead.

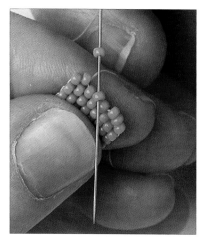

17. Continue working to the end of the row.

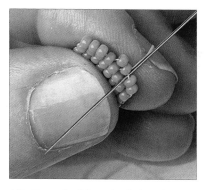

18. To end with a single bead, continue decreasing at the beginning and end of each row until only two beads remain in the row.

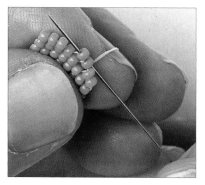

19. Go back through these two beads and loop under the thread at the edge.

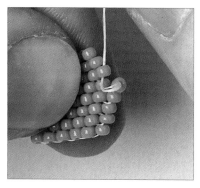

20. Add the final bead to make a point.

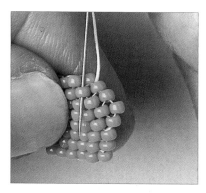

21. Finish off by weaving your way back through three or four beads, following the path of the thread.

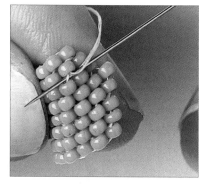

22. Loop the needle under a thread between two beads.

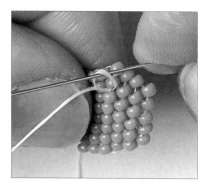

23. Pull the needle through and pass it back through the loop you have just formed.

24. To complete your work, remove the stopper bead, weave any excess threads through three or four beads into the body of your work and snip off the ends.

Starting a new thread

To start a new thread part of the way through your work, pass it through a bead three or four beads back, knot it around the thread between two beads and then weave it back up the beadwork, knotting it around the thread path.

Brick stitch

This beading technique gets its name from the pattern it creates, which resembles a brick wall. It is also known as Comanche stitch as it was, and still is, a very popular technique used by Native American beaders. Brick stitch is extremely versatile and I have used it to create all sorts of beaded pieces, including small baskets and pots.

Brick stitch creates a firm and even piece of work because each bead is woven through twice. It is not as quick as peyote stitch and is therefore more suitable for small projects such as earrings, bracelets and needlecases.

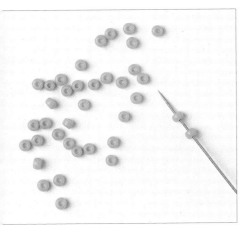

1. Create the foundation row. Thread your needle with approximately 90cm (36in) of waxed thread, pick up two beads and slide them to about 15cm (6in) from the end of your thread. This tail of thread can be woven into your work later.

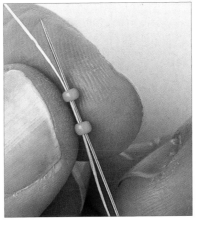

2. Take your needle round and back through both beads.

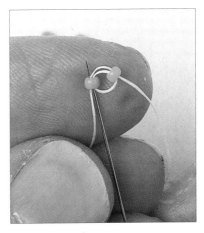

3. Pull the thread tight, then take the needle round and back through the first bead you threaded on and once again tighten the thread.

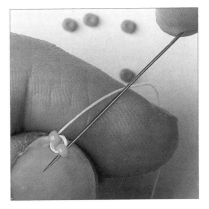

4. Take the needle through the other bead and pull the thread tight.

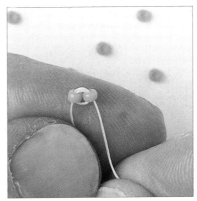

5. The two beads are now separated so that they sit next to each other. You are now ready to start the ladder stitch.

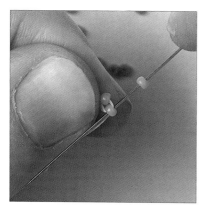

6. Begin the ladder by picking up a third bead and passing the needle round and back through the second bead you threaded on.

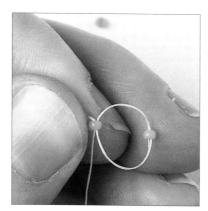

7. Pull the thread tight.

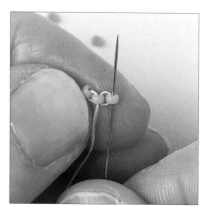

8. Knock the bead into position, so that it is lying next to the previous one, and take the needle up through the bead you just added.

9. Pull the thread tight, pick up another bead and pass the needle round and back through the previous bead.

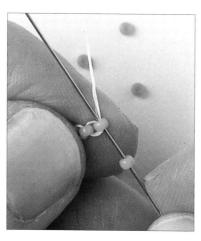

Tip

Always pass the needle through a bead on the opposite side from which your thread is coming out.

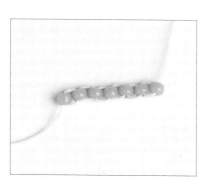

10. Repeat steps 6 to 9 until your foundation row is the required length.

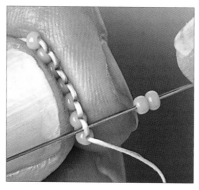

11. To begin the next and subsequent rows, pick up two beads and take the needle under the threads joining the last two beads of the previous row.

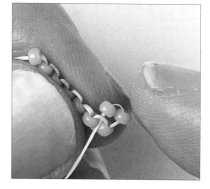

12. Pull the thread through and knock the last bead into position – so that it sits between the last two beads of the previous row.

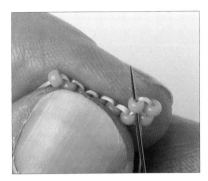

13. Pass the needle back up through the last bead you added.

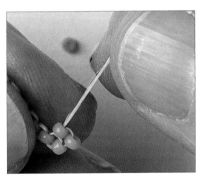

14. Pull the thread tight.

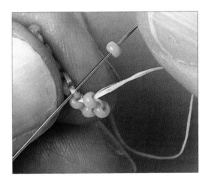

15. Pick up the next bead, first taking the needle under the threads joining the next two beads in the previous row, as in step 11.

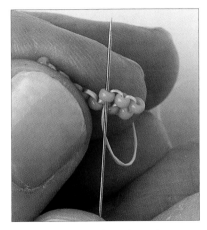

16. Tighten the thread, and secure the bead by passing the needle back up through it.

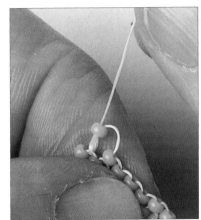

17. Continue to the end of the row.

18. Continue backwards and forwards across your work until it is the required depth. Here I have worked seven rows. Finish off by weaving in any loose threads, following the instructions on page 28.

Increasing and decreasing

Decrease at the beginning of a row by adding one bead instead of two. If you need to decrease within the work, skip the part where you add a bead and go under the joining thread. Continue in this way until you have decreased by the required amount.

Increase at the end of a row by going through the end loop twice. To do this, pick up a bead and go under the last thread at the end of the row and back up the bead just added. Then pick up another bead and go under the same thread and back up the bead just added. Continue increasing at the end of each row until you have increased by the required amount.

Circular brick stitch

Circular brick stitch creates a flat circle that can be used as a base for tubes like the Harlequin Needlecase (see below). Work in a circle, starting in the centre and increasing in each row.

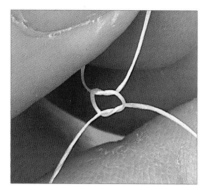

1. Form a loop about 15cm (6in) from the end of your thread and secure it with a slip knot.

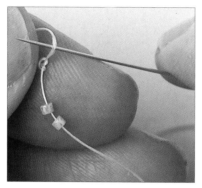

2. Thread the needle and pick up two beads. Pass the needle through the loop.

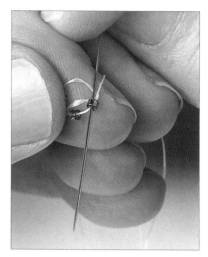

3. Tighten the thread and pass the needle back through the last bead you added.

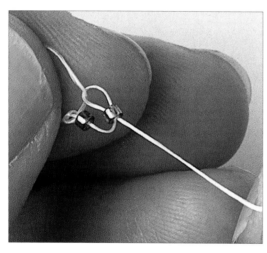

4. Pull the thread tight.

The Harlequin Needlecase (page 76) uses circular and tubular brick stitch to cover the wooden form.

5. Pick up another bead, pass the needle through the loop and then back through the bead, as before.

6. Pull the thread tight.

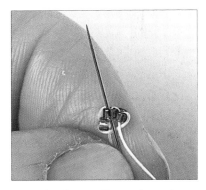

7. Pull the loop closed, drawing the three beads into a circle.

8. Take the needle through the first bead you threaded on to secure the circle.

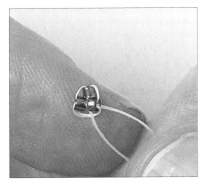

9. Tighten the thread.

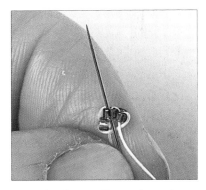

10. Take the needle up through the next bead (bead two). The foundation row is now complete.

11. Pull the thread through and begin the next row (row one). Pick up two beads and pass the needle under the thread joining the first two beads of the foundation row.

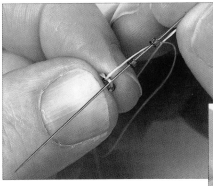

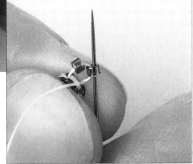

12. Tighten the thread, knock the beads into position, then pass the needle back up through the last bead you threaded on.

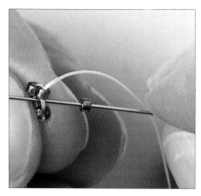

13. Continue around the circle, adding beads to fill the gaps. Sometimes two beads will be needed to fill a gap, sometimes only one, thereby gradually increasing and widening the circle, but always add the beads individually, not two at a time.

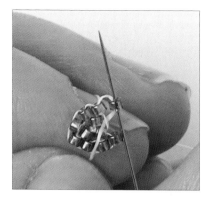

14. Add the final bead of row one to complete the circle.

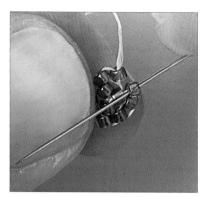

15. Finish row one by taking the needle down the first bead in the row ...

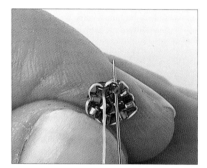

16. ... and up through the second bead.

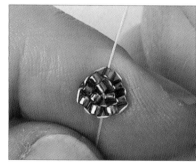

17. The circle is now complete and you are ready to start the next row.

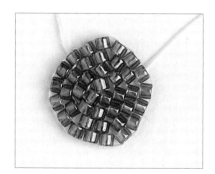

18. Complete as many rows as you need to make your circle the correct size.

Tubular brick stitch

Tubular brick stitch is worked in the same way as circular brick stitch, without increasing. By keeping the tension tight, the beads will gradually pull up into the shape of a tube.

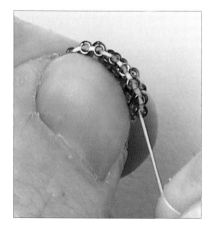

Right-angle weave

Right-angle weave, also know as RAW, has an open weave and a beautiful fluid structure. This stitch builds up very quickly, with each bead sitting at a right angle to those adjacent to it, and the thread passing at right angles through the beads to join them.

The basic stitch consists of groups of four beads, however right-angle weave can be made with any multiple of four, for example eight or twelve beads. The necklace project on page 90 uses eight beads.

Four bead right-angle weave

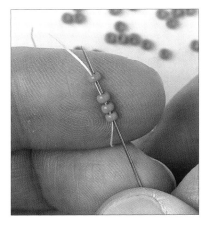

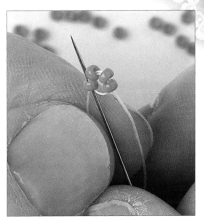

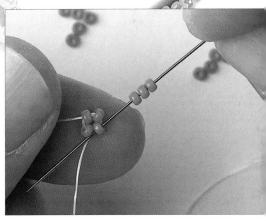

1. Thread your needle with approximately 90cm (36in) of waxed thread. Pick up four beads and slide them down towards the end of the thread, leaving a 15cm (6in) tail. Take the needle round and back through all four beads to secure them.

2. Pull the beads taut to create a circle, and take the needle through the first bead you threaded.

3. Pass the needle through the next two beads and pull the thread through, coming out from the third bead you threaded on, opposite the bead with the tail thread. Pick up another three beads and take the needle round and back through the same bead.

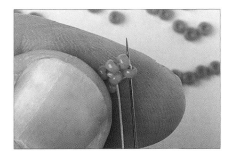

4. Pull the thread tight and push the beads into place. Pass the needle back through the first of the three beads you added in this round.

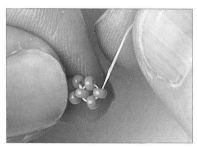

5. Take the needle and thread through the second bead you threaded on so that it is now emerging from the last bead in the chain.

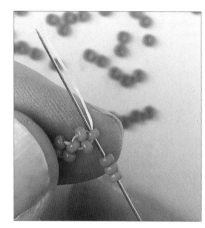

6. Pick up three more beads and take the needle round and back through the same bead.

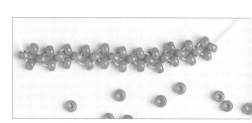

7. Repeat steps 5 to 7 until the chain is the required length.

Eight bead right-angle weave

This form of right-angle weave is worked in exactly the same way as the four bead version, except using eight beads for each round rather than four.

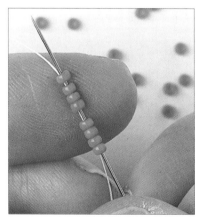

1. Pick up eight beads. Slide the beads down towards the end of your thread, leaving a 15cm (6in) tail that can be woven into your work later. Pass the needle round and back through all eight beads to secure them.

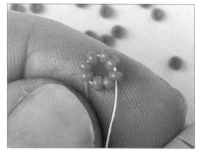

2. Pull the thread tight to form a circle of beads. Manoeuvre them into position with your fingers if you need to. Take the thread back through six beads, leaving two with only one thread going through them.

3. Pick up six beads and take the needle round and back through the two beads that your thread is coming out from.

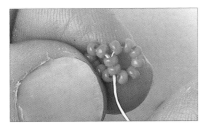

4. Pull the thread taut, creating a second circle of beads joined by two common beads.

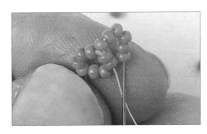

5. Continuing round in the same direction, take the thread through four of the previous six beads you added.

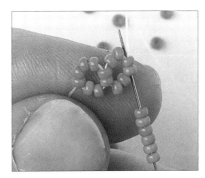

6. Pick up another six beads and pass the needle round and back through the last two of these four.

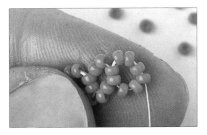

7. Pull the thread taut to form another circle.

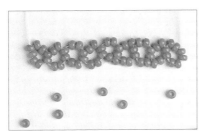

8. Continue in the same way until the chain is the desired length. Finish off by weaving in any remaining thread following the method described on page 28.

This Classic Pearl project (pages 90–95) clearly demonstrates eight bead right-angle weave.

Bead netting techniques

Bead netting has an attractive open weave that is useful for covering large areas quickly. It is used not only for jewellery, but also for edging and finishing lampshades and soft furnishings. Bead-netted jewellery was extremely popular in Victorian times, when it was also used for edging sleeves and collars.

There are two main types of netting stitch: one involves weaving through the beads, known as **bead-through netting**, and the other involves looping around the thread between the beads, known as **looped netting**. Weaving through the beads is a variation of peyote stitch (see pages 25–28) in which more beads are added in each stitch to create loops of beads. The most common form, and the one I have used in several of the projects in this book, consists of three-bead loops. Five- or seven-bead looped netting is also popular; the more beads the larger the loop or net.

There must always be an odd number of beads in a loop. The middle bead of each loop is the link bead, and this is the bead that is woven through to join the rows together. The first row of beads (the foundation row) is made up of an uneven number of beads plus a link bead, for example if you are making a three-bead netted piece, the foundation row needs to be divisible by four – three beads per net plus a link bead.

Bead-through netting can be either horizontal, weaving backwards and forwards across the work, or vertical, weaving up and down the work.

Saraguro collar from Ecuador (see pages 8–11).

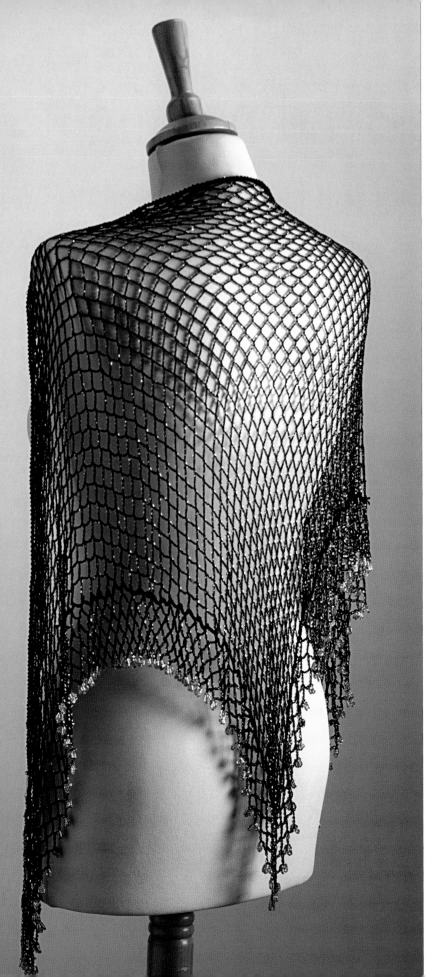

*Crocheted bead-netted
shawl, circa 1930s.*

Three-bead horizontal netting

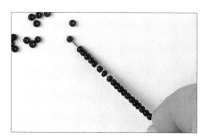

1. Thread your needle with approximately 90cm (36in) of waxed thread, pick up a stopper bead and slide it down to approximately 15cm (6in) from the end of the thread. Go through the stopper bead again to secure it. Pick up enough beads for the width of your beadwork, in multiples of four. For this demonstration I used twenty beads.

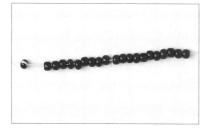

2. Slide the beads down to the stopper bead.

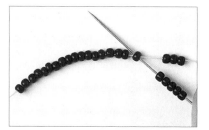

3. Pick up five beads for the first turn (the number of beads in the netting plus two), and take the needle back through the fourth to last bead you threaded on.

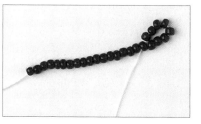

4. Pull the thread tight to form a loop of beads.

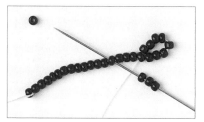

5. Pick up three more beads and pass the needle through the fourth bead along, working back towards the end of the thread.

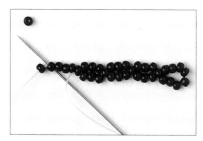

6. Pull the thread tight and repeat to the end of the row.

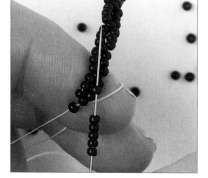

7. Working back along the net, pick up five beads for the turn, and take the needle through the middle bead of the last loop in the previous row.

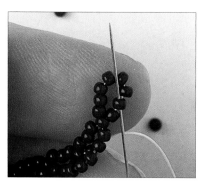

8. Pull the thread tight to form a loop and continue in the same way to the end of the row.

9. Complete as many rows as you need (here I have completed four rows of netting) and finish off following the instructions on page 28.

Increasing and decreasing

To increase or decrease within a piece of bead-through netting, you
simply need to add to, or take away from, the beads either side of the
link bead. To decrease at the beginning of a row, miss out the first loop
by weaving through and coming out at the next link bead in the row.
To decrease at the end of a row, just work one less loop and turn to
begin the next row before
reaching the end.

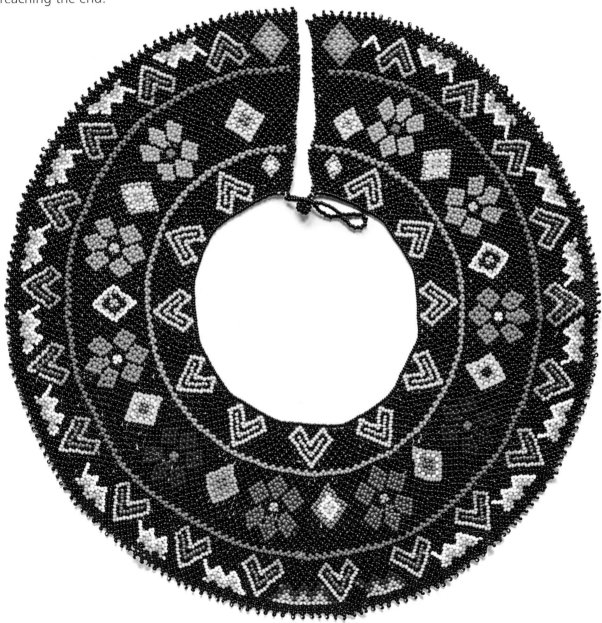

Beautifully crafted Ecuadorian collar, demonstrating increasing within rows.

Three-bead horizontal tubular netting

This technique creates a tube that can be used to make a bag or purse, such as Frodo's Purse on page 68. It is worked in a spiral, moving along one loop at the beginning of each row.

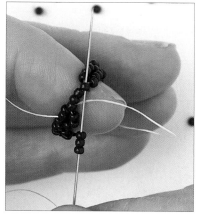

1. Thread the needle and pick up enough beads to form the circumference of your tube. Here I have used thirty-two. Take the needle round and go back through all of the beads.

2. Pull the thread taut to form a circle of beads.

3. Pass the needle through two or three beads to secure the circle. Pick up three beads and take the needle through the fourth of the next four beads along, working towards the tail of the thread.

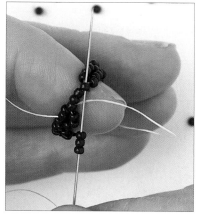

4. Pull the thread taut to form a loop. Continue to the end of the row, picking up three beads and passing the needle through every fourth bead along.

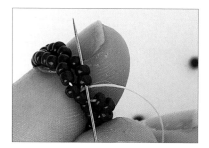

5. Complete the row by passing the thread through the two beads at the start of the row. This puts you in the correct position to start the next row.

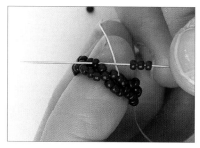

6. Continue the next row following the same method as the first.

7. Build up the rows until your work is the required depth. Finish off following the method on page 28.

Vertical netting

This type of netting is most commonly used for edging and fringing or to join two pieces of beadwork together, as in Frodo's Purse on page 68. Here I have demonstrated vertical netting as an edging to a piece of beadwork. I have used two different-coloured beads – one as the main colour and the other (the link bead) as the contrast.

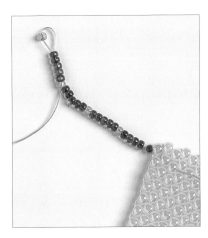

1. Weave a thread through your work, coming out where you wish to start your netting. Pick up five main-colour beads, one contrast, five main-colour and another contrast bead. Slide them down to the end of your thread. Go back up the last five main-colour beads you threaded on and the next contrast bead.

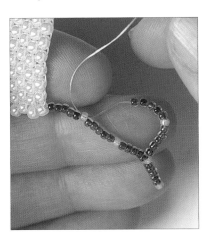

2. Pick up five main, one contrast and five main-colour beads. Miss out the next contrast bead of the previous row and pass the needle through the next contrast bead along.

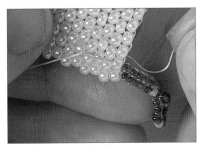

3. Pick up five main-colour beads, go through the next bead along on the edge of your work, and come out through the next.

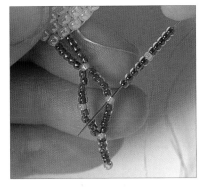

4. Pick up five mains, one contrast and five mains, and take the needle back down the second contrast bead of the previous row.

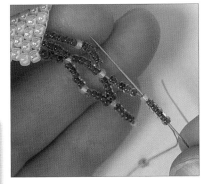

5. Pull the thread through, pick up a further five main-colour beads, one contrast, five main-colour beads and one contrast, and go back up through the last five main-colour beads and the second contrast bead you added on.

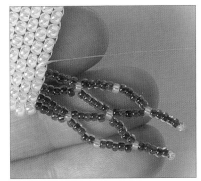

6. Continue working up and down until your netting is the required depth.

Tip

This is a simple example of vertical netting. Use different numbers of beads to create a longer net, and vary the colours and styles of the beads to achieve different effects.

Chevron chain

Chevron chain is another form of woven netting that has an attractive pattern. Here I have used two contrasting colours to create a striking neckband. Just make the band long enough to suit your neck size and attach a clasp to either end. I have finished this piece off using an attractive centre fringing.

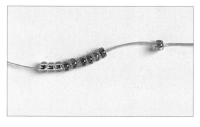

1. Secure a main-colour stopper bead approximately 15cm (6in) from the end of the thread. Pick up six main-colour beads and three contrast beads.

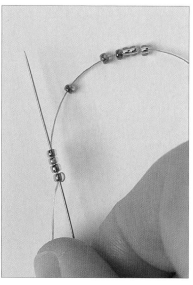

2. Take the needle back up through the stopper bead and a further three main-colour beads.

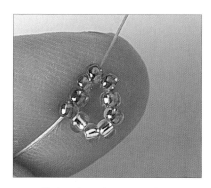

3. Pull the thread tight to form a triangular shape.

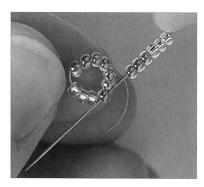

4. Pick up three contrast and three main-colour beads, and go back up the first main-colour bead you added in the previous round.

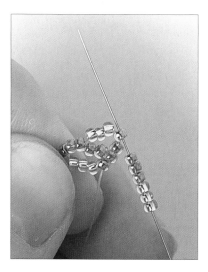

5. Pick up a further three contrast and three main-colour beads and, again, go back through the first main-colour bead you added in the previous round.

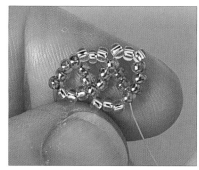

6. Continue in the same way until your chain is the required length.

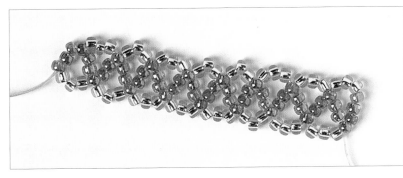

Completed first row of the chevron chain.

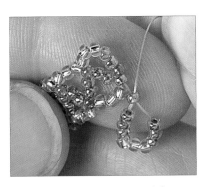

7. To begin the next row, pick up four main-colour, three contrast and three main-colour beads. Go round and back through the first bead you added.

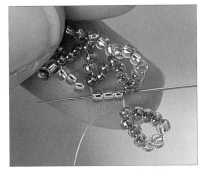

8. Go across and through the first three contrast beads of the previous row.

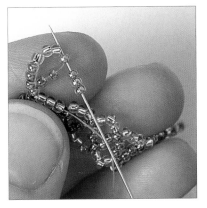

9. Pull the thread through. Pick up three main-colour beads and go down through the fourth main-colour bead you added in the previous round.

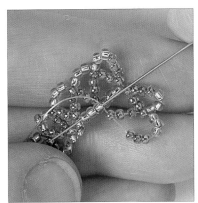

10. Pull the thread through to form a full chevron. Pick up three contrast and three main-colour beads, and take the needle back up the first main-colour bead you added in the previous round. Take the needle through the next three contrast beads of the previous row.

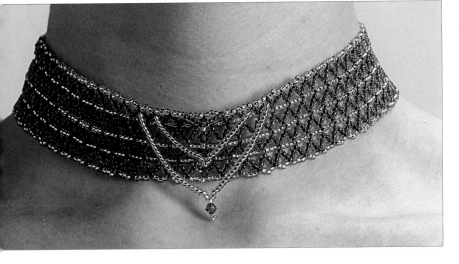

11. Continue to the end of the row. Repeat until the chevron chain is the required depth. Add a simple fringe using pages 48–51 for ideas, and a clasp to complete the neckband.

Looped netting

As weaving through the beads is an extension of peyote stitch, looped netting is an extension of brick stitch. Rows and loops are created by adding beads, then taking the thread under the thread of the previous row and going back through the last bead added. The principles of increasing, decreasing and tubular work are the same as those outlined on page 41.

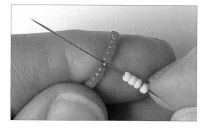

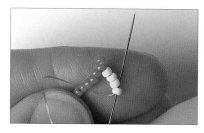

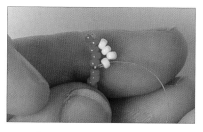

1. Thread the needle with approximately 90cm (36in) of thread, pick up a bead and slide it to about 15cm (6in) from the end of the thread. Go through the stopper bead again to secure it. Pick up as many beads as required for the foundation row (shown in red in this example). Pick up an even number of beads for the first row of loops (here I have used four), and pass the needle under the foundation row, between the fifth and sixth beads, and loop your thread over the foundation row thread.

2. Pull the thread through and go back down the last bead added.

3. Pull the thread through, creating the first net. Note the loop of thread around the foundation row.

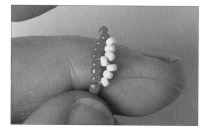

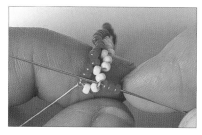

4. Pick up another three beads, loop the thread under the foundation row after the third bead along, then take the needle back through the last bead added.

5. At the end of the row, loop the thread under the foundation row, as before, and pass the needle back through the last bead added. To start the second row of loops, pick up three beads (shown red in this example) and take the needle under the previous row, halfway between the last four beads.

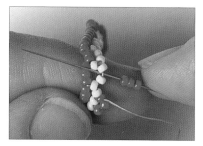

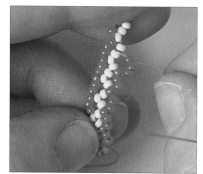

6. Pull the thread through and go back down the last bead added. Pick up another three beads and take the needle under the previous row, halfway along the next loop as before.

7. Continue working back and forth across the work.

Tip

To make more open nets, use more beads, but remember always to use an even number of beads in the nets of the first row.

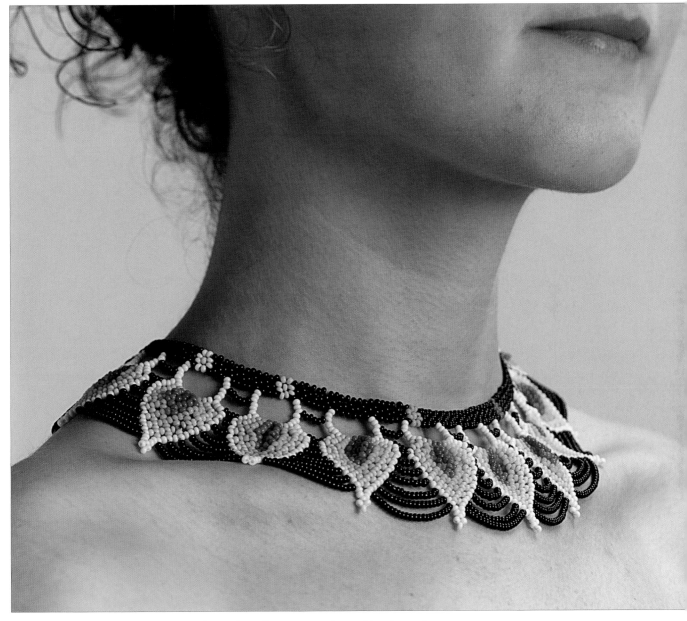

Pretty collar demonstrating a simple looped netting pattern. Owned by the author.

Fringing & finishing

In my opinion, this is an essential part of bead netting; there is nothing more disappointing than a beautifully executed piece of beadwork that looks unfinished simply because it needs some attractive fringing.

Here I have covered some basic fringing and finishing techniques, but with fringing there are no hard-and-fast rules. Be creative, and experiment with different types, colours and shapes of beads.

The bracelet below was created using the chevron chain (see pages 44–45) and finished with a simple fringe.

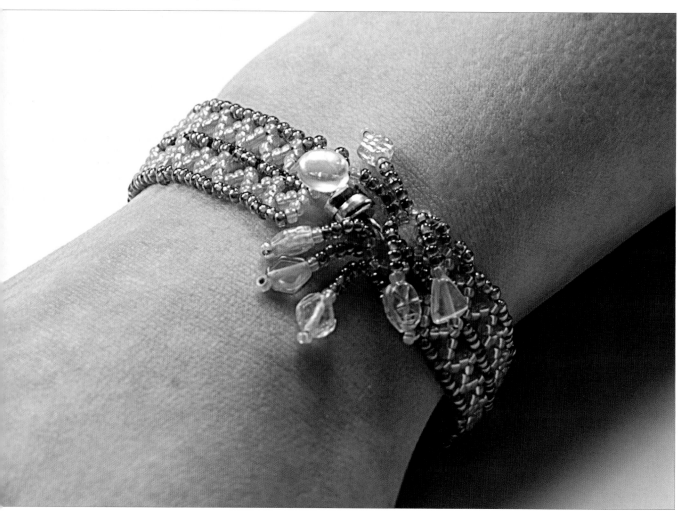

Simple fringing

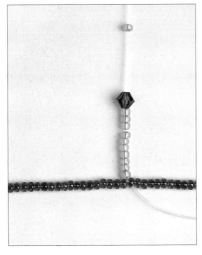

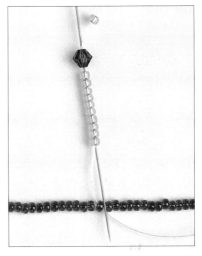

1. Decide at which point on the edge you wish to add a fringe, and pass a needle and thread through a bead at that point.

2. Pick up as many beads as you need to make the fringe. I chose ten main-colour beads, followed by a purple feature bead, then another main bead. Slide them to the base of the fringe, adjacent to the edge of your work.

3. Pass the needle back through all the fringing beads, apart from the last one you threaded on.

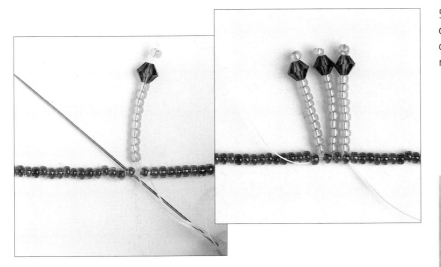

5. Continue until you have the desired number of fringes. Finish off by weaving back into the main body of the work.

4. Pull the fringe taut and pass the needle through the next bead along, at the point at which you wish to place the next fringe.

Tip

Be creative with your fringing – pass the thread through two or three beads if you wish to leave a gap between each fringe; vary the lengths of the fringes and experiment with different types of bead.

Looped fringing

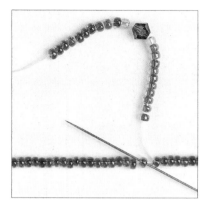

1. Start by passing a thread through a bead on the edge you wish to fringe. Pick up the beads for the loop (in this case ten main-colour beads, followed by a single contrast bead, a feature bead, another contrast bead and ten more main-colour beads), and pass the needle through the next bead along.

2. Pull the thread through to create a loop.

3. Create a series of loops along the edge of your work, moving from bead to bead and leaving no gaps in between. Vary their lengths for a more interesting effect. Finish off by weaving back into the main body of the work.

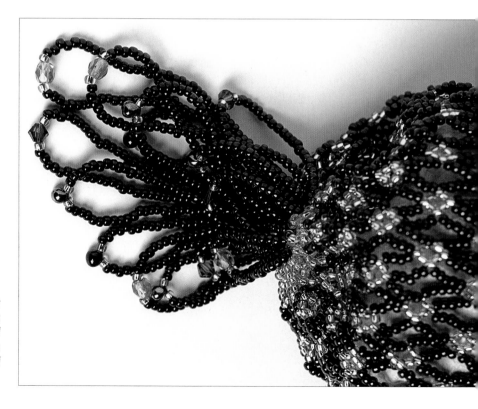

The Varna Evening Bag project (page 82) demonstrates looped fringing. I have varied the amount of beads, and the types of feature beads, used in each loop.

Spiked fringing

This type of fringing can be used to create an unusual and striking effect. Again, use your imagination and be creative!

1. Begin by weaving a thread through your work, coming out where you wish to start the fringe. Pick up as many main-colour beads as you need for the length of your fringe (I have used twenty) and slide them down to the edge of the work.

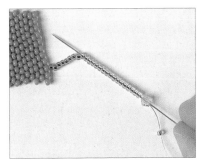

2. Pick up a feature bead and another main-colour bead and go back up through approximately fifteen beads.

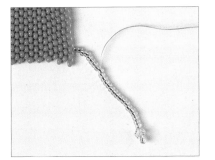

3. Pull the thread through.

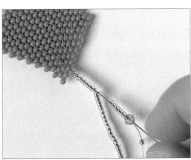

4. Pick up five main-colour beads, another feature bead and another main-colour bead. Take the needle back through these beads, then through the first five beads you threaded on, then finally through the first bead on the edge of your work.

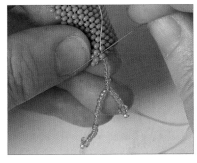

5. Pull the thread through and loop it around a thread in the main body of your work to anchor it.

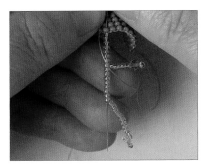

6. Take the needle back down approximately twelve beads of the fringe.

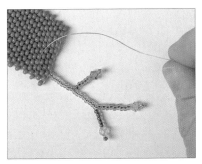

7. Pull the thread through, pick up five beads in a second colour, a feature bead and another second-colour bead, and go back through these beads, as you did in step 4. Finish off by weaving the thread through the main body of the work and cut it off.

Daisy chain

This form of chain is so-named as it resembles a row of daisies. It can be used as edging, for straps and even bracelets. I have used Delica beads here in two complementary colours, though any beads are suitable.

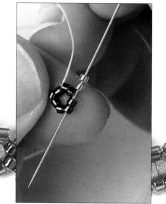

1. Thread the needle with waxed thread and pick up eight beads in the main colour.

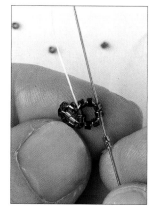

2. Take the needle round and back through all eight beads and pull them tightly into a circle. Pass the thread through another two beads to secure it.

3. Working back in the opposite direction, pick up two beads in the contrasting colour and pass the needle through the fourth and fifth beads along.

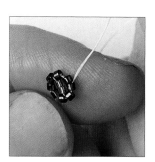

4. Pull the thread tight and push the two contrast beads into position in the centre of the circle.

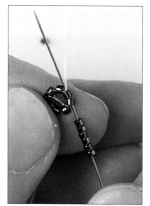

5. Pick up six more beads in the main colour, and take the needle round and back through the two beads in the circle from which the thread is emerging.

6. Pick up two of the contrast beads, take the thread back in the opposite direction and pass it through the fourth and fifth beads along.

7. Pull the thread tight, manoeuvre the beads into position and continue until the chain is the desired length. Finish off following the instructions on page 28.

Spiral chain

Like the daisy chain, this design can be used to make edgings, straps and simple bracelets. Use two colours – one for the inner core of the chain and the other spiraling round the outside.

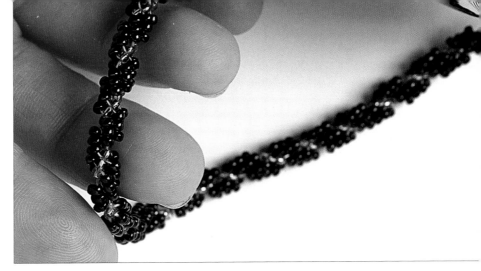

Spiral chain strap for the Varna Evening Bag (page 82).

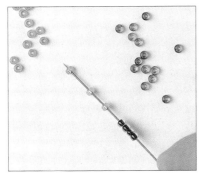

1. Thread the needle and pick up four of the inner (brown) beads and then three of the outer (pink) beads.

2. Slide the beads down the thread, leaving a 15cm (6in) tail at the end, and tie them round in a circle.

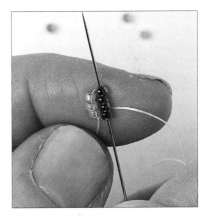

3. Pass the needle back up through all four inner beads.

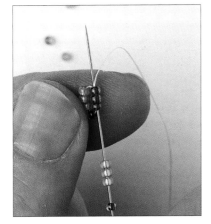

4. Pull the thread through, then pick up another three outer beads and one inner bead. Take the thread round, and pass it back up through the last three of the four inner beads.

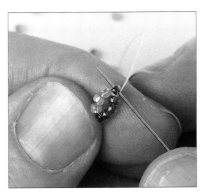

5. Take the needle back through the last inner bead you added.

6. Repeat steps 4 and 5 until the chain is the required length, then finish off your work following the method on page 28.

Netted Bracelet

Here is a simple horizontal netted bead bracelet. The twist in the bracelet is achieved simply by increasing the number of beads in the loops. See the section on horizontal netting on page 40.

You will need

10g Miyuki seed beads, size 11, emerald green (code 331) (contrast bead)

5g Miyuki seed beads, size 11, jade green (code 411) (main colour)

Twenty-five 4mm oval faceted feature beads

One large shaped bead to be used as a fastener/toggle

Nymo thread, size D, in a complementary colour

Size 10 beading needle

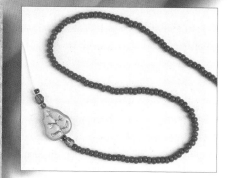

1. Thread your needle with approximately 90cm (36in) of thread. Attach a stopper bead (see page 25) and thread on enough beads in the main colour for the size of your wrist. Thread on a feature bead, a contrast bead, a leaf-shaped bead, a contrast bead, a feature bead and another contrast bead to make a toggle.

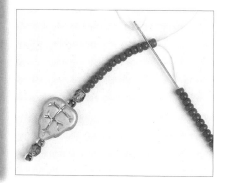

2. Take the needle back through all the beads, excluding the last bead you threaded on.

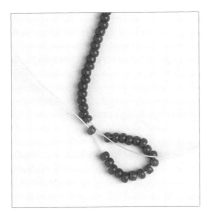

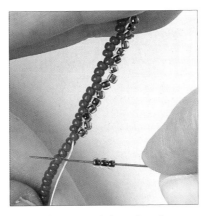

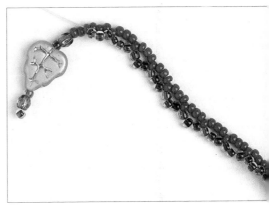

3. Pick up eighteen main-colour beads and pass the needle back through the first one to make a loop. You can vary the size of the loop so that it fits comfortably and securely over the toggle.

4. Work a row of three-bead horizontal netting using the contrast beads (see pages 40–41).

5. Leave a short length of chain (approximately two or three beads) at the end.

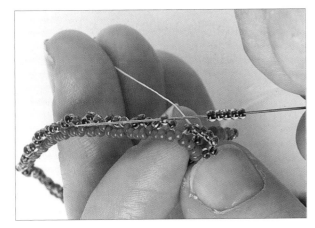

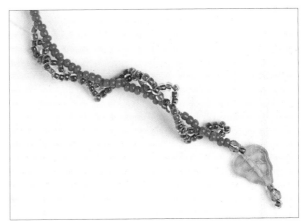

6. Turn and work your way back along the bracelet in the opposite direction, this time including five contrast beads in each loop instead of three (in other words, a five-bead net). Take the needle through the middle bead of each loop in the previous row, as before.

7. As you work, the bracelet will begin to twist.

8. Work the next row as a seven-bead net using contrast beads, and the final row as a seven-bead net with three main-colour beads, one feature bead and three main-colour beads. (The feature beads are larger than the other beads, so you are continuing to increase the size of the net.) To finish, weave through the loop to reinforce it, weave in any loose threads and snip off the ends.

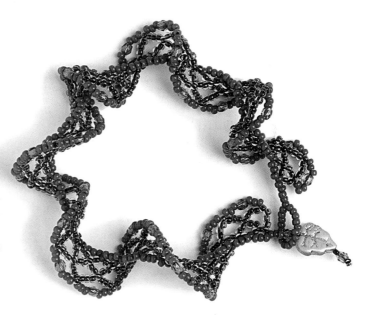

Lindisfarne Book Cover

A recent visit to the island of Lindisfarne in the north-east of England inspired this book cover. I was struck by the spirituality of the island, said to be the birthplace of Christianity in Britain. The ancient ruins of the abbey and the museum are filled with Celtic symbolism.

This book cover would be ideal for a personal diary or address book. I made a basic book cover from undyed leather and then sewed the beaded panel to it; you can, of course, use any material for the cover that is to hand. The pattern can be adapted to fit most sizes of book by increasing or decreasing the number of main-colour rows at the top or bottom of the piece, or widening it by increasing the foundation row in multiples of four beads.

This pattern is very straightforward and will enable you to practise simple horizontal netting and following a netting pattern.

You will need

50g Miyuki seed beads, size 11, light gold crystal (code 251)(main colour)

10g Miyuki seed beads, size 11, matt dark red (code 141)

10g Miyuki seed beads, size 11, metallic purple (code 469)

Nymo thread, size D, in a complementary colour

Size 10 beading needle

Piece of undyed leather, large enough to make your book cover

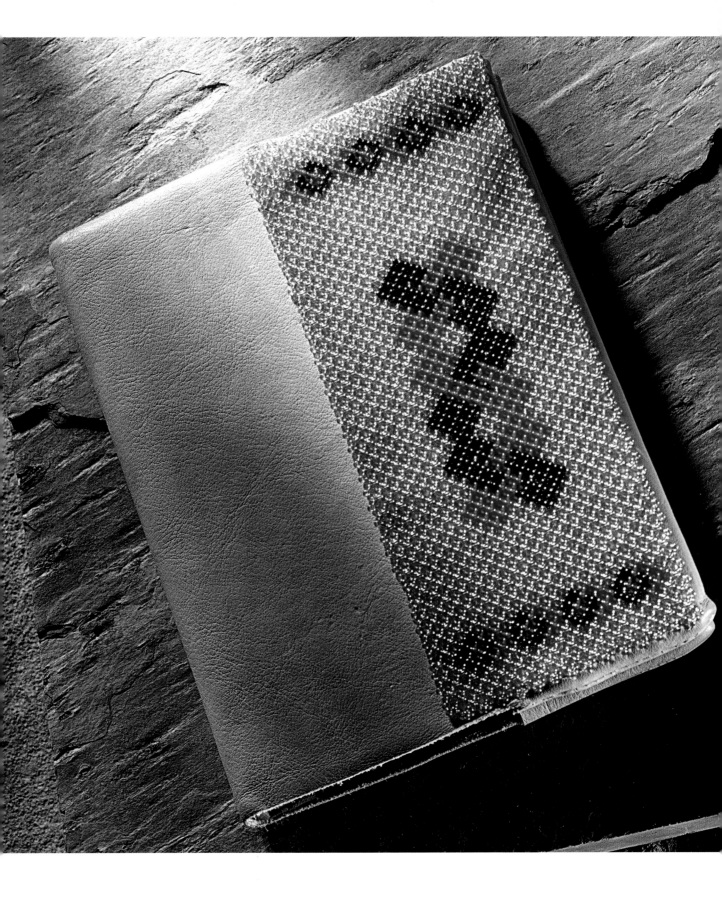

Turn

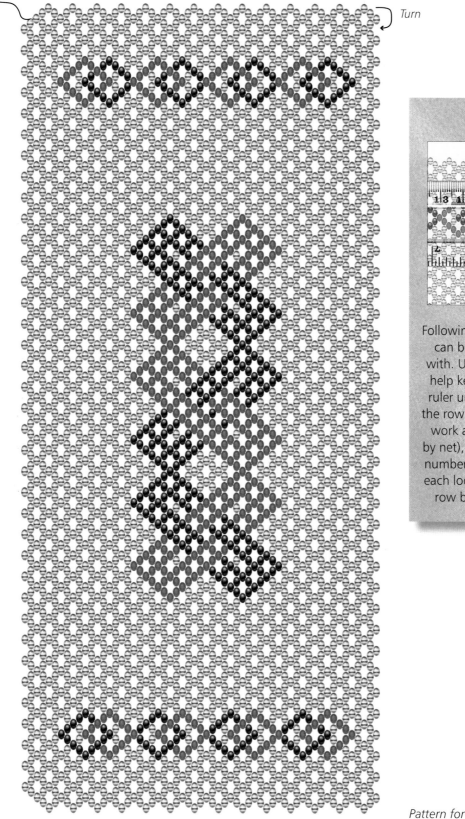

Tip

Following a bead netting pattern can be a little tricky to begin with. Use a transparent ruler to help keep on track. Align your ruler under the linking bead of the row you are working on, and work across loop by loop (net by net), threading on the correct number and colour of beads for each loop. Move the ruler down row by row as you progress.

Pattern for the book cover.

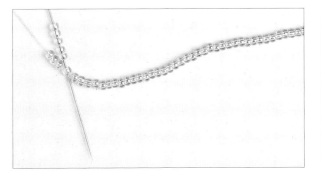

1. Thread your needle with approximately 90cm (36in) of waxed thread, add a stopper bead and pick up fifty-six beads in the main colour. This is known as the foundation row. Pick up five further main-colour beads for the turn, and pass the needle through the fourth bead along in the foundation row.

2. Continue to the end of the row using three-bead horizontal netting (see pages 40–41). Repeat for a further two rows using main-colour beads.

3. Begin the pattern in the fourth row. Work two loops of the net using main-colour beads, then for the next loop pick up one main-colour bead, one red and one main-colour bead. Continue following the pattern to the end of the row.

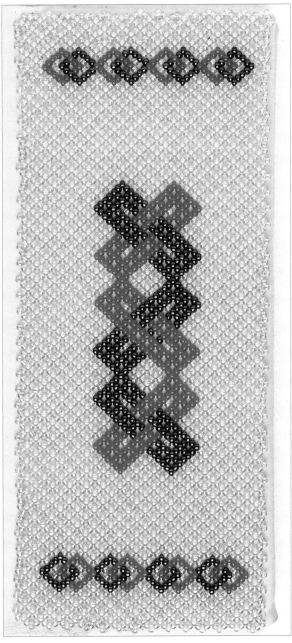

4. Continue to follow the pattern for the remaining rows. Finish off in the usual way. Repeat the steps in exactly the same way to create another flat piece for the back of the book cover.

Beaded Cuff

This pretty cuff is reminiscent of ethnic jewellery with its vibrant colours and elaborate fringing. Like the Lindisfarne book cover on page 56, it is made using three-bead horizontal netting. The pattern is slightly more complicated, with the addition of several more colours. The piece is finished with a simple fringe and fastened with loops and toggles.

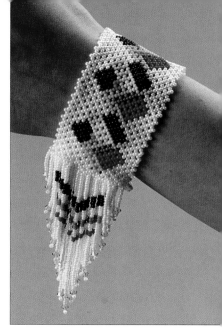

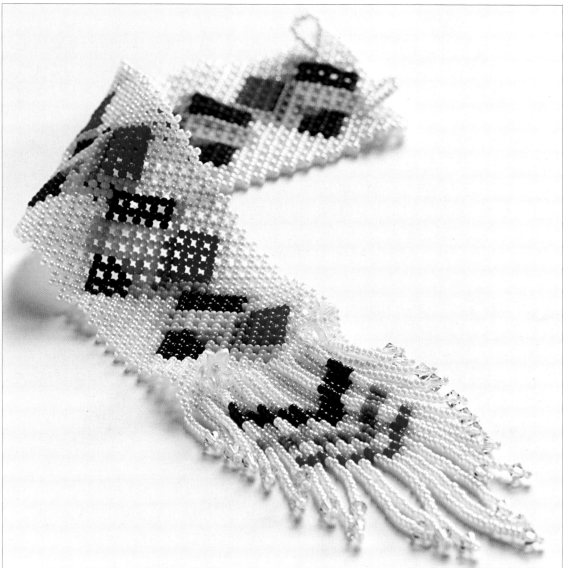

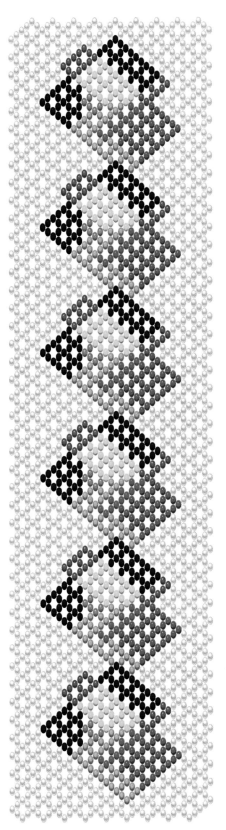

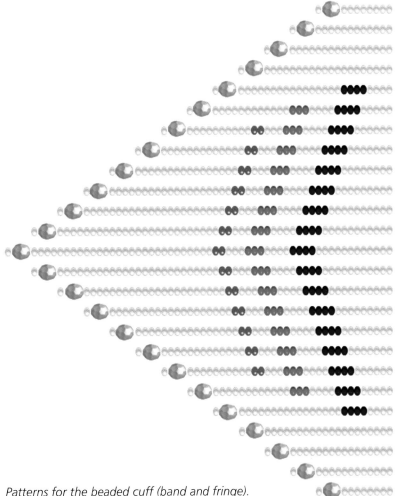

Patterns for the beaded cuff (band and fringe).

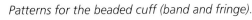

Tip

Remember to lay a transparent ruler across the pattern directly underneath the row you are working on to avoid losing your place. Move the ruler down row by row (net by net) as you progress.

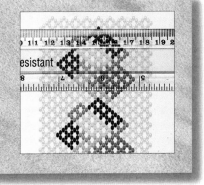

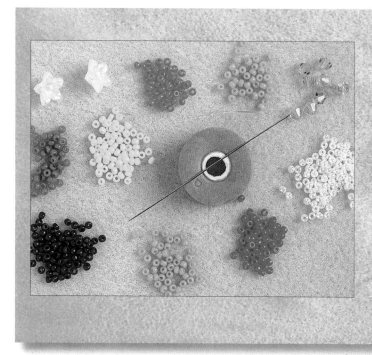

You will need

30g Miyuki seed beads, size 11 white Ceylon (code 528) (main colour)

5g of each of the following size 11 Miyuki seed beads: yellow opaque (code 404), light orange opaque (code 406), red opaque (code 407), jade green opaque (code 411), turquoise blue opaque (code 413), cobalt blue opaque (code 414) and chartreuse opaque (code 416)

Twenty-five 4mm crystal beads

Two shaped feature beads to be used as fasteners/toggles

Nymo thread, size D, in a complementary colour

Size 10 beading needle

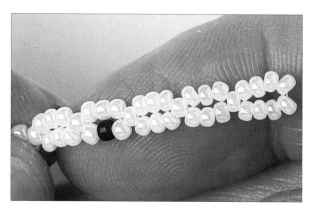

1. Thread the needle with approximately 90cm (36in) of waxed thread and pick up thirty-six main-colour beads. This is the foundation row. Pick up a further five main-colour beads for the turn, and go through the fourth bead along in the foundation row.

2. Work the first row using three-bead horizontal netting (see pages 40–41). Follow the pattern carefully, placing a blue bead in the centre of the fourth loop. Continue working back and forth across the work following the pattern.

3. Finish off by adding the fastening loops as follows. They need to be large enough to fit comfortably over the toggle beads. Begin by weaving a thread through your work to the place where you wish to put the first loop (approximately 1cm, or ½in, from the top edge of the cuff). Pick up as many beads as you need to make the loop (I've used eighteen) and slide them down to the end of the thread.

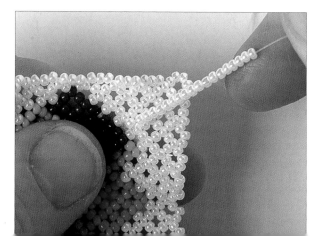

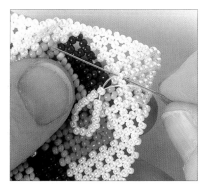 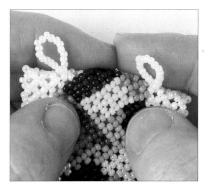

4. Go back through the first bead you added and pull the thread taut to form a loop. Pass the thread through each bead in the loop again to strengthen it, then take the needle back through the bead connecting the loop to the main body of the work.

5. Weave the thread through each bead in the row until it is in the correct position for the second loop. Make this loop in the same way as the first.

6. To attach the first toggle bead, weave a thread through your work to the correct position for the toggle bead (approximately 1cm, or 1/2in, from the lower edge of the cuff). Pick up three white beads, one toggle bead and another white bead. Slide the beads down to the end of the thread. Missing out the last bead added, take the needle back through the toggle bead, the three white beads and the bead joining the toggle to the cuff.

7. Pull the thread taut. Strengthen the toggle by passing the thread through each bead again. Weave the thread through to the correct position for the second toggle. Attach the second toggle in the same way as the first.

8. Using the basic fringing technique described on page 49, follow the pattern on page 61, adding the number and colour of beads as indicated.

Dom Pedro Wallhanging

This wallhanging was influenced by a holiday in Portugal; the hotel interior had lovely terracotta stone flooring and wonderful rich-coloured furnishings. The beauty and vibrancy of this sunflower reminds me of that room.

This is another version of simple horizontal netting, but unlike the previous two projects I have added decorative edging to the finished piece in addition to a fringe on one edge.

Begin by making the main netted rectangular panel following the pattern on page 66. Remember to mark your place on the pattern using a transparent ruler, moving it down row by row as you progress. Using the edging colour, add two straps at the top, which can be used to make loops in which to hang the piece from a tapestry pole. Finally, add the pattern extensions along the sides and base and embellish with a combination of looped and simple fringing (see pages 49 and 50).

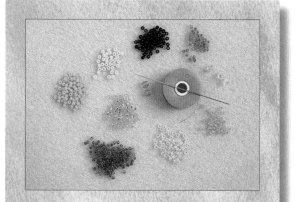

You will need

15g Miyuki seed beads, size 11, yellow opaque (code 404)

10g of each of the following size 11 Miyuki seed beads: dark rose (code 336) and dark brown opaque (code 409)

5g of each of the following Miyuki seed beads, size 11: amber transparent (code 132), green-lined yellow (code 374), chartreuse opaque (code 416), gold-lined salmon (code 553) and gold-lined white (code 577)

Small tapestry pole (optional)

Three 4mm oval faceted beads

Nymo thread, size D, in a complementary colour

Size 10 beading needle

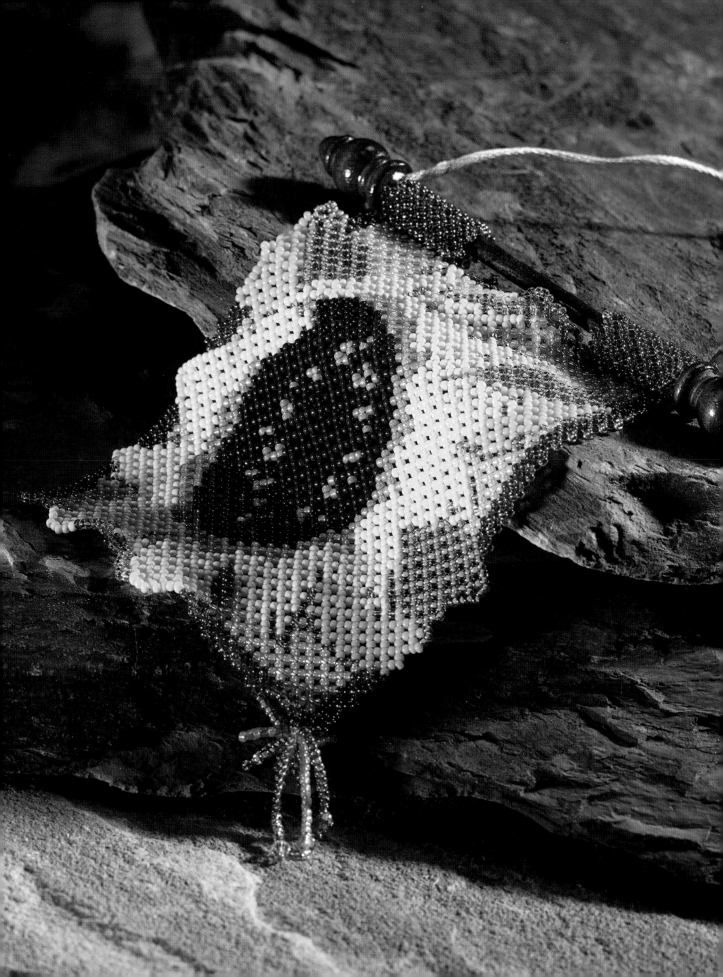

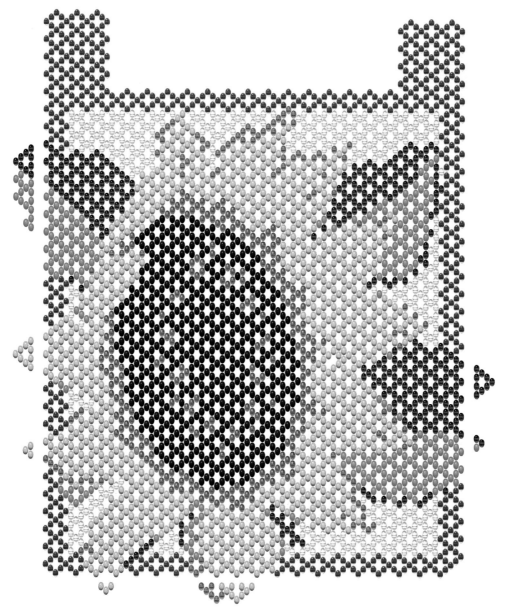

Pattern for the Dom Pedro wallhanging.

1. To begin the edging, weave in a new thread, bringing it out through the first dark green bead on the right-hand side of the panel.

2. Pick up three dark green beads, and take the needle through the middle bead of the next dark green loop.

Right-hand edging. *Left-hand edging, top.* *Left-hand edging, bottom.*

3. Continue working the right-hand edging following the pattern on page 66. To finish, weave the thread through and cut it off. Complete the lower and left-hand edging in the same way.

Lower edging (turned through 90°).

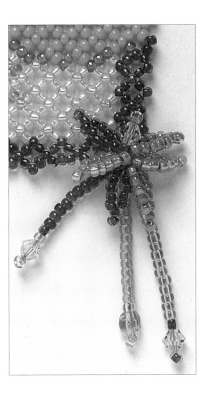

4. Attach the decorative fringing to the bottom right-hand corner using seven loops and three simple fringes of various lengths. I used the pink, gold, green and dark rose beads and crystals for the fringing, using between nine and eighteen beads for each fringe.

5. Form the loops at the top of the wallhanging by sewing them down into the main body of the work.

Frodo's Purse

I am an avid fan of *The Lord of the Rings* trilogy and decided to name this piece after the main character. The design on the purse is a simple Celtic pattern. The purse is a larger version of what used to be known as a miser's purse. Very popular in the Victorian and Edwardian era, miser's purses can be worn on a belt or carried. To open the purse, pull back the rings, open the gap and place your money in either bag; to close it, simply slide the rings back to the centre again.

Begin this project by making two identical bags using horizontal tubular netting (see page 42), varying the colours in the design if you wish to, and then join them together using vertical netting (see page 43).

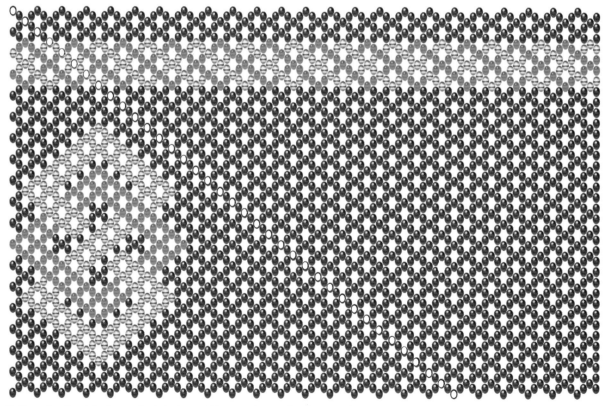

Pattern for Frodo's Purse. In tubular netting, each row begins one loop (or net) over. The white dots on the pattern represent the start of each row.

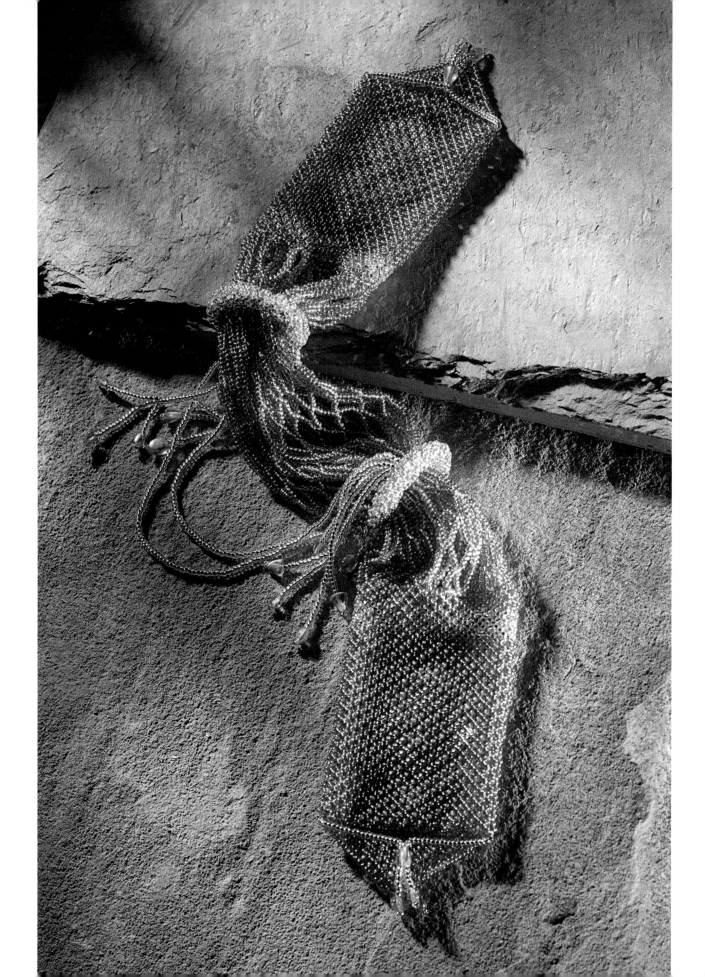

You will need

75g Miyuki seed beads, size 11, dark amethyst gold lustre (code 318) (main colour)

10g of each of the following size 11 Miyuki seed beads: silver-lined gold (code 02) and green transparent (code 341)

16cm (6¼in) of 3mm cord

Twenty assorted 4mm faceted and feature beads

Sticky tape

Nymo thread, size D, in a complementary colour

Size 10 beading needle

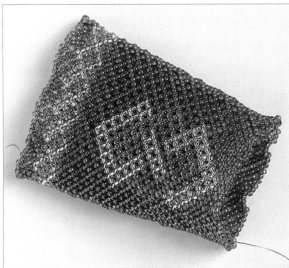

Tip

Remember to lay a transparent ruler across the pattern to mark your place, moving it down row by row (net by net) as you work.

1. Begin each bag by picking up ninety-six beads in the main colour, then taking the needle back through all the beads and drawing them into a circle. Leave a tail thread of 15cm (6in). Make each bag using three-bead tubular netting (see page 42). Starting from the top, follow the pattern on page 68. Work your way down in a spiral, bearing in mind that in tubular netting each row begins one loop (or net) over.

2. To sew up the base, weave in a new thread, coming out through the middle bead of the first net on one edge of the bag. Pick up a main-colour bead, then take the needle through the middle bead of the first net on the other side of the bag.

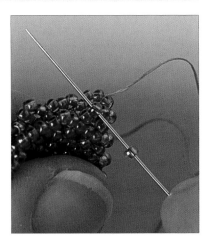

3. Pull the thread through, pick up another main-colour bead, and take the needle through the middle bead of the next net along on the opposite side.

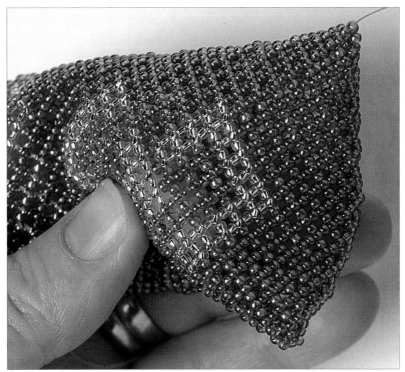

4. Continue to the end, and then weave the thread back through to the beginning to strengthen the seam.

5. To start the point on the base of each bag, turn the bag over so the back is facing upwards and weave through a new thread, coming out through the middle bead of the first net. Pick up three main-colour beads and take the needle through the middle bead of the next net along.

6. Pull the thread tight to form a three-bead net and continue along the base of the bag, picking up three beads and passing the needle through the middle bead of each subsequent net (see page 40).

7. When you reach the end of the row, loop under the thread between the current bead and the next bead along on the base of the bag.

8. Go back through the last bead you went through and the last two beads you added on. This is the first decrease.

9. Pull the thread through and continue working to the end of the row.

10. To decrease again, go under the thread after the last bead you went through, then go back through that bead and the last two beads you added (just as you did in step 8).

11. Continue in the same way, working backwards and forwards across the work, until only a single three-bead net remains. Finish by weaving the thread through and cutting it off.

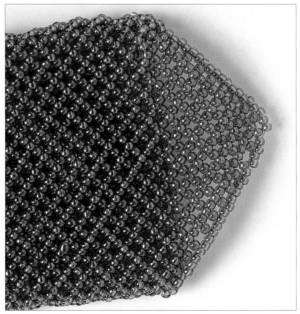

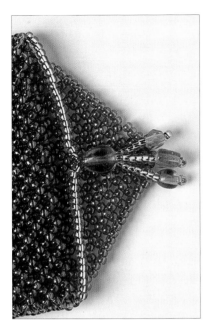

12. Start the fringing at one corner of the main body of the bag by picking up twenty-one gold beads, a feature bead, seven gold beads, a feature bead and a gold bead. Weave back through to the last of the twenty-one gold beads added, then make the second gold string in the same way and join it to the opposite corner of the purse. Weave back through, coming out through the first feature bead added, and make another two simple fringes. Weave back through the first string of gold beads and finish off in the usual way.

13. Begin the vertical netting joining the two bags together. Weave a thread through to the edge of one of the bags, coming out through the middle bead of the net just to the right of the centre. Pick up five main-colour beads, one green, five main-colour, and one gold bead. Continue picking up beads in this order, finishing on five main-colour beads, until the string of beads is approximately 18cm (7in) long.

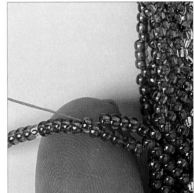

14. Pass the thread through the equivalent bead on the edge of the other bag. This is row one.

15. Pull the thread through, pick up five main-colour beads and pass the needle through the last contrast bead you added in the first row.

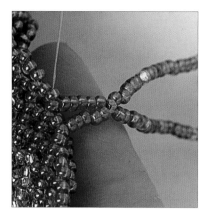 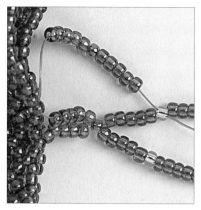 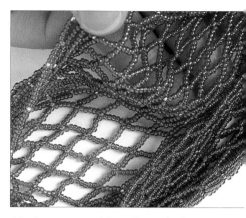

16. Pick up the same number of beads as between the first and last contrast beads of row one, and in the same sequence (five main-colour beads, one gold, five main-colour beads, one green, etc.). End with five main-colour beads. Pass the thread through the first contrast bead of the first row, then pick up five more main-colour beads and take the needle through the middle bead of the next net along on the edge of the bag.

17. Pick up five main-colour beads, one green and five main-colour beads, and pass the needle through the second contrast bead along in the previous row.

18. Repeat step 17 to the end of the row. When you reach the edge of the bag, pass the thread through the middle bead of the next net along and work back again. Continue working in vertical netting until you have gone all the way round the edge of each bag.

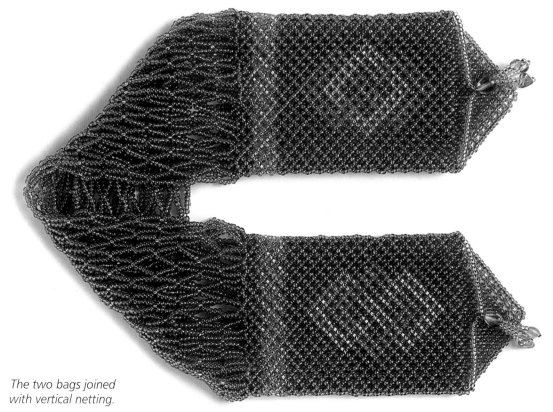

The two bags joined with vertical netting.

19. For each of the green rings, cut a length of 3mm cord approximately 8cm (3in) long. Seal the ends together with sticky tape to stop them fraying and stitch them in place, wrapping the thread around the loop several times as you sew to secure it.

20. Pick up twelve green beads on the same thread, make a ring around the cord and go back through all twelve beads.

21. Work your way around the cord using three-bead tubular netting (see page 42).

22. Join the two ends together using the same method you used to join up the base of each bag.

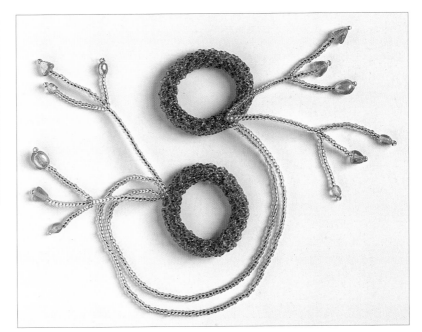

23. To join the two rings together, begin by weaving through one ring, coming out at the outer edge. Pick up enough gold beads to make a string the same length as the vertical netting plus a little extra, and weave into the second ring. Create a spiked fringe on the first ring using faceted and feature beads (see page 51). Once you have completed the fringing on this ring, pick up enough gold beads to form a string of similar length to the first string. Connect the string to the second ring and make a second spiked fringe. To complete the purse, roll one of the bags lengthways, pass it through one of the rings and push the ring to the centre. Repeat for the other bag.

Harlequin Needlecase

In this project I have used Delica beads. These are more expensive than ordinary seed beads, but give a very neat, flat finish and are well worth the expense. Several techniques are used: circular and tubular brick stitch with seven-bead tubular netting laid over the top for the needlecase, and daisy chain for the strap. With the final addition of some pretty floral feature beads and a fringe, the overall effect is stunning.

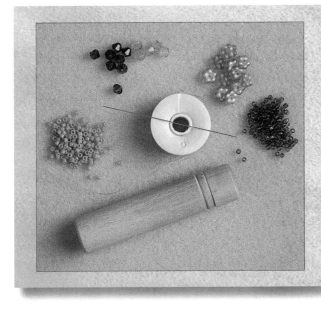

You will need

20g Delica beads, size 11, dusky pink (code 210) (main body colour)

15g Delica beads, size 11, transparent amethyst (code 117) (contrast body colour)

Seventeen 4mm small floral shaped beads

Ten 4mm crystals, pink

Seven 4mm crystals, amethyst

Small wooden needlecase

Nymo thread, size D, in a complementary colour

Size 10 beading needle

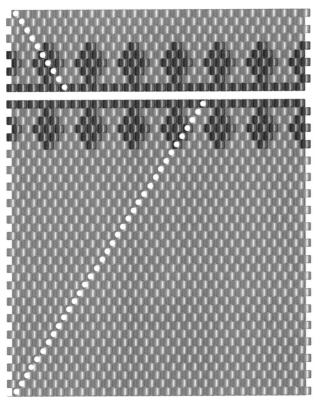

The patterns for the cap and main body of the needlecase. I have marked the beginning of each row with a white dot. Start each part at the top of the pattern and work down. You will notice that you are working in a spiral, moving half a bead across when you start each new row.

Tip

Place a transparent ruler across the pattern to mark your place, moving it down one row at a time. Remember you are moving over one bead in each row.

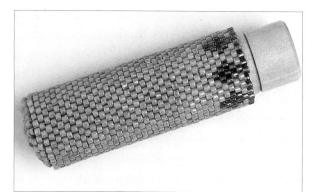

1. Begin by making the base of the needlecase, worked in circular brick stitch (see pages 32–34). Build up the circle until the outer edge contains twenty-eight main-colour beads, then start to work the body of the needlecase in tubular brick stitch (see page 34) following the pattern provided. When you have completed the body, fit it over the wooden needlecase.

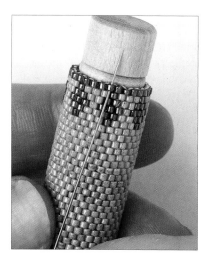

2. To begin attaching the netting to the needlecase, rethread the needle and take the needle up through a bead just to the left of one of the diamond tips.

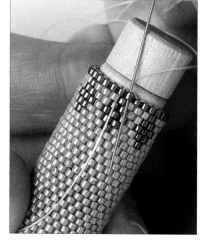

3. Take the needle down the next bead along, to the right (just to the right of the diamond tip).

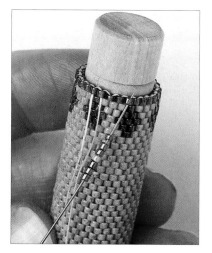

4. Pull the thread tight leaving a 15cm (6in) tail. Pick up three main-colour beads, one contrast and three more main-colour beads and take the needle up through the bead just to the left of the next diamond.

5. Pull the thread into a loop, and take the needle down the next bead along.

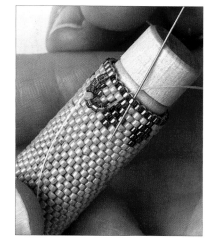

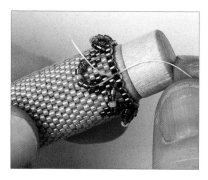

6. Continue round, finishing the first row by taking the thread up through the bead you started from.

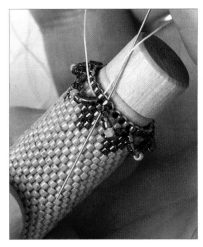

7. Take the needle down the next bead along (just to the right of the diamond tip).

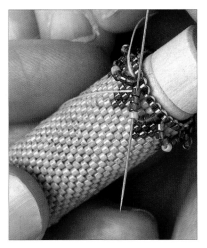

8. Pull the thread tight and begin the next row. Take the needle down through the first three main-colour beads and the contrast bead at the start of the first loop to the right.

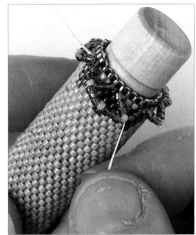

9. Pick up seven beads in the same pattern as before and create a loop by taking the needle through the next contrast bead along in the first row.

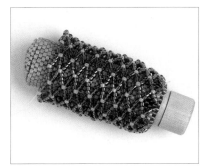

10. Continue the netting until it reaches the bottom of the needlecase when slightly stretched (approximately sixteen rows).

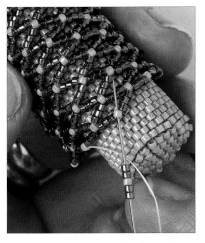

11. Start to decrease by threading on only five beads for the next loop (two main-colour, one contrast and two main-colour beads).

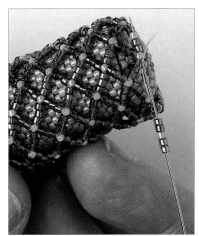

12. Complete the row by picking up five beads and taking the needle through the first contrast bead of the previous row, and then the first two main-colour beads and the first contrast bead of the current row.

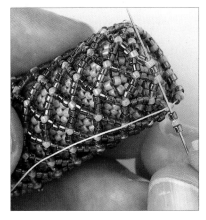

13. In the next row, continue to decrease by using only three beads for each loop (one main-colour, one contrast and one main-colour).

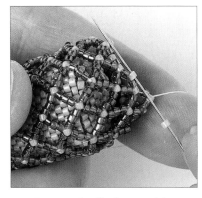

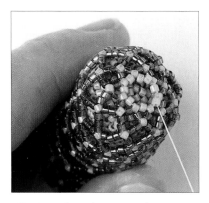

14. To start the final row, pick up a single contrast bead and pass the needle through the next contrast bead along in the previous row.

15. Complete the row, using contrast beads only, then pass the thread through each bead once more to tighten and secure them. Leave the thread attached for the fringe.

16. To make the fringe, pick up twenty main-colour beads, a crystal bead and another main-colour bead. Slide the beads down to the end of the thread, then, missing out the last bead added, go back through all the beads.

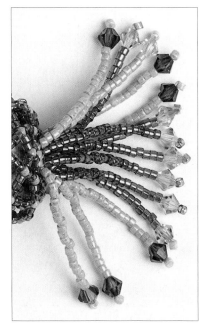

18. To embellish the net, choose where you wish to place the first flower and weave the thread through the beads of the net to that position. Pick up a main-colour bead, a flower bead and another main-colour bead, slide them to the bottom of the thread, then pass the needle back through the flower and the first main-colour bead to secure them.

17. Pass the needle through the next bead along in the last row of netting and pull the thread tight to make the fringe. Repeat this all around the base of the netting, varying the colour of the beads.

19. Continue weaving through the net, adding flowers in a random pattern.

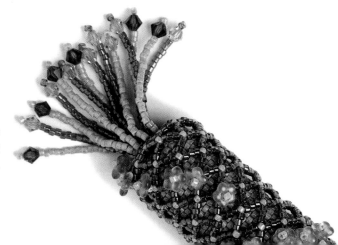

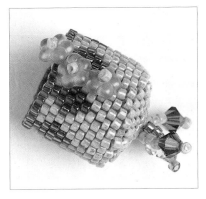

20. The cap is simply a small version of the inner part of the needlecase, embellished with flower beads and three short tassels consisting of three beads, a crystal and a single bead, attached to the end.

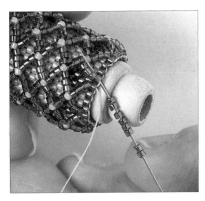

21. To attach the strap, first join a loop to the rim of the needlecase. Pass the thread up through a bead, pick up eight beads in the main colour and take the needle back down through the next bead along.

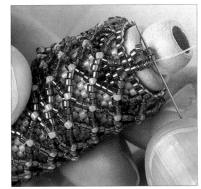

22. Pull the thread tight to form a loop, then take the needle and thread back up through the first three beads to secure it. Pass the needle through the next two beads.

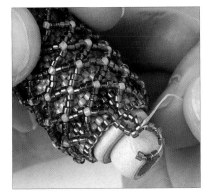

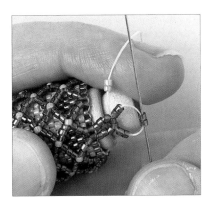

24. Pick up two contrast beads, take the thread back in the opposite direction and pass it through the two beads opposite those joining the two loops.

23. Pick up six beads in the same colour, and take the needle round and back through the same two beads on the previous loop. Tighten the loop. This forms the beginning of the daisy chain strap.

25. Continue the daisy chain until the strap is the required length. Secure it to another loop made on the other side of the needlecase.

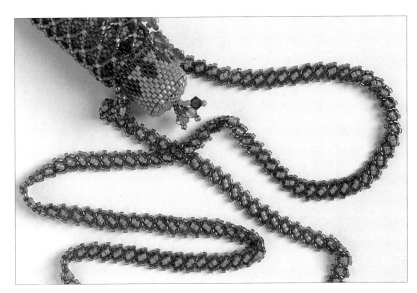

Varna Evening Bag

This project was influenced by the lovely Paralelos collar made by the Saraguro beaders of Ecuador. I adapted the stitch to make an evening bag. I took the bag with me when I went on holiday to Varna, a region of Bulgaria. I fell in love with the country and the Bulgarian people, and this project reflects their rich and vibrant culture.

You will need

100g Miyuki seed beads, size 11, purple iris (code 455) (main colour)

50g Miyuki seed beads, size 11, silver-lined gold (code 02) (contrast colour)

Thirty 4mm crystals

Ten 4mm feature beads

A large concertina lid for the purse

Undyed leather for lining the bag (optional)

Nymo thread, size D, in a complementary colour

Size 10 beading needle

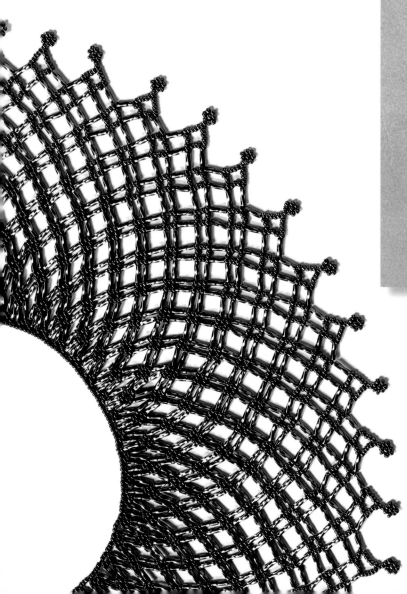

The Paralelos collar (see page 9).

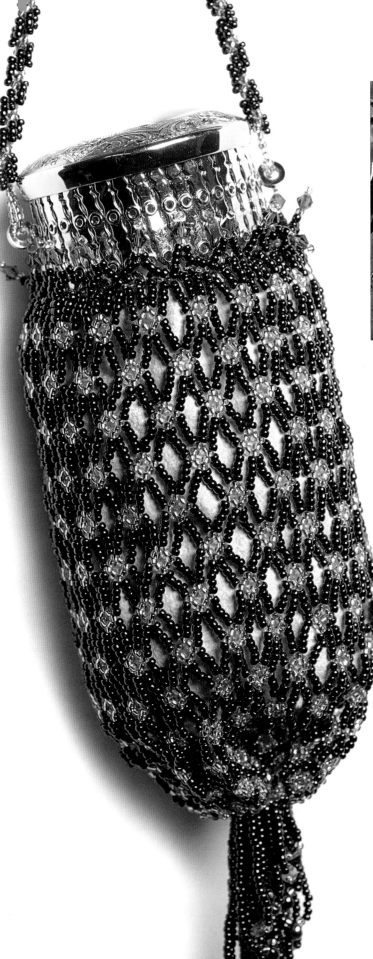

1. To attach a thread to the purse frame, first thread a needle and pass it through one of the holes round the base of the frame.

2. Pull it through leaving a 15cm (6in) tail. Pick up one contrast bead and take the needle back through the hole – the bead serves to anchor the thread.

3. Begin stage 1 of the foundation row by picking up four contrast beads and taking the thread through the next hole in the frame. Pass the needle from the outside of the frame inwards.

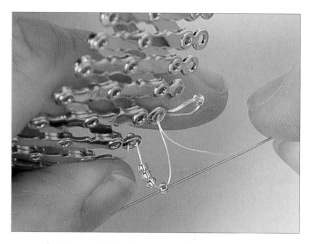

4. Pick up another contrast bead (the anchor bead) and take the needle back through the hole and the last bead added. Pull the thread through.

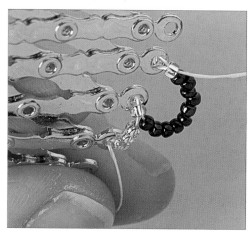

5. Pick up ten main-colour beads and a contrast bead. Go through the next hole along, pick up an anchor bead, and go back through the hole and the last contrast bead added. Tighten the thread.

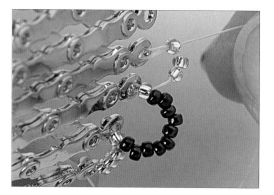

6. Pick up three contrast beads. Go through the next hole along, pick up an anchor bead, and go back through the hole and the last contrast bead added.

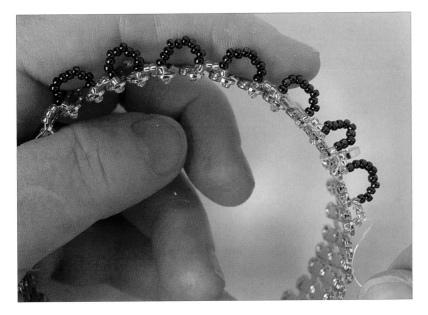

7. Work your way around the top of the purse, repeating steps 5 and 6.

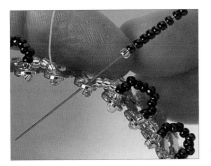

8. For the final loop, pick up a contrast bead and ten main-colour beads and pass the needle through the first bead in the row, then through the hole, and finally through the anchor bead.

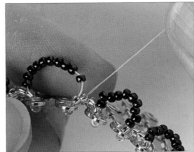

9. Take the needle back through the hole and the first and second contrast beads. You are now ready to start the next row (row one).

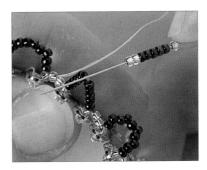

10. Pick up one contrast bead, five main-colour beads and two more contrast beads. Take the needle under the thread halfway along the first loop of the previous row.

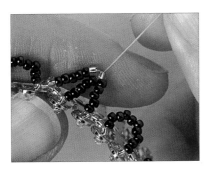

11. Loop over the thread and take the needle down the last contrast bead you added.

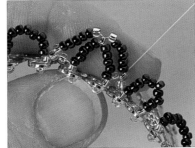

12. Pick up one contrast bead, five main-colour beads and one contrast bead, and pass the needle under the thread between beads two and three of the next loop (of contrast beads). Loop over the thread and go back down the last contrast bead added.

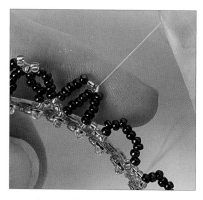

13. Pick up five main-colour beads and two contrasts. Loop the thread over the next loop along, between beads five and six, and go back down the last contrast bead added (as in steps 10 and 11).

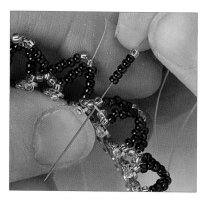

14. Repeat steps 12 and 13 to the end of the row. Complete the row by picking up one contrast bead and five main-colour beads and taking the needle back up the first contrast bead of the current row and under the thread between beads two and three of the gold loop.

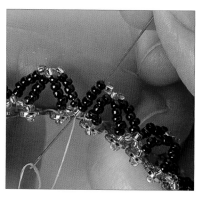

15. Loop over the thread and go back down the contrast bead and first five main-colour beads of row one. You are now in the correct position for row two.

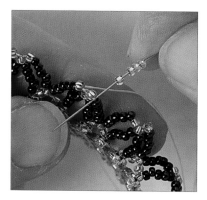

16. Pick up four contrast beads and loop under the thread between the third contrast and the next main-colour bead of the previous row.

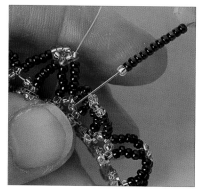

17. Go back down the last contrast bead you added. Pick up ten main-colour beads and one contrast bead and loop under the thread between the fifth main-colour bead and the first contrast bead of the previous row.

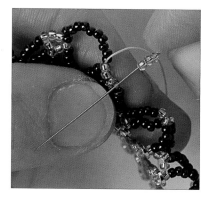

18. Pull the thread through and go back down the last contrast bead you added. Pick up three contrast beads, and loop under the thread between the third contrast bead and the first main-colour bead of the previous row.

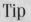

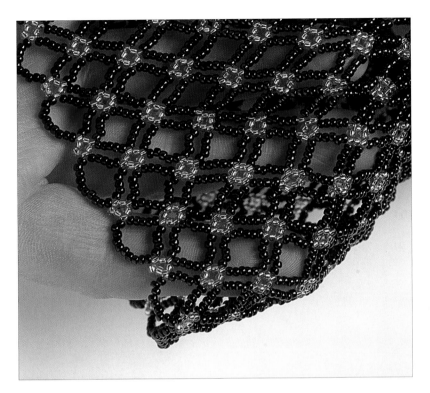

19. Repeat steps 17 and 18 to the end of row two. Finish the row as you ended the foundation row (see steps 8 and 9). Repeat rows one and two until you have completed twenty rows. Make sure you end on a row two.

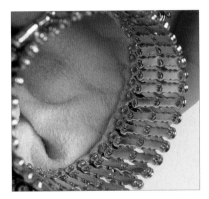

20. If you are lining the purse, make a pouch out of undyed leather that is slightly shorter than the purse and with a base the same diameter as the open frame. Attach it to the frame by sewing through the anchor beads.

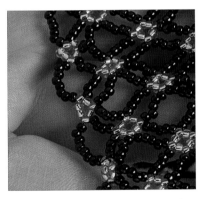

21. Begin the decrease to form the end of the purse. Decrease by one main-colour bead in each row one (i.e. four, three, two, etc.) and by two main-colour beads in each row two (eight, six, four, etc.). Continue to decrease until there are no main-colour beads left. The photograph above shows a row two with eight main-colour beads in each loop. Now begin decreasing the gold beads, ending with only one bead in each stitch. Close up the bag using circular brick stitch and go round the row twice.

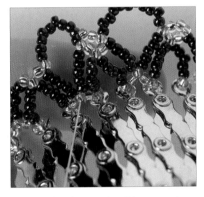

22. Add a decorative fringe to the top of the purse. Start by weaving through a length of thread, bringing it out through the middle bead of one of the gold loops in the foundation row.

Tip

For clarity, steps 22 to 24 have been demonstrated before completing the main body of the work.

23. Pick up five main-colour beads, one contrast bead, one crystal and one contrast bead. Go back through the last contrast bead and the crystal, pick up five more main-colour beads and take the thread down the middle bead of the next gold loop.

24. Loop around the thread and go back down the same bead. Pull the thread through ready to begin the next loop.

25. Repeat steps 23 and 24 to complete the fringing.

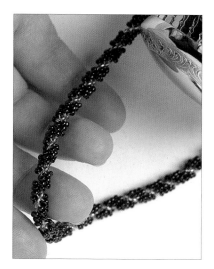

26. Add fifteen graduated loops to the base of the purse using main-colour beads and a central embellishment of two gold beads either side of a crystal or feature bead.

27. The strap is a spiral chain (see page 53), approximately 20cm (8in) long.

28. Join the strap to the bag using loops of gold beads.

The Varna Purse

This is a smaller version of the Varna Evening Bag, made in exactly the same way using 30g of turquoise green and 15g of gold size 15 Miyuki seed beads.

Classic Pearl Necklace & Earrings

This beautiful jewellery, with its simple, classical styling, could be worn by a bride at her wedding. It incorporates three different techniques: peyote stitch, right-angle weave and netting.

You will need

15g Miyuki seed beads, size 11, white Ceylon (code 528)

String of pearlised rice beads

Five 4mm milky white crystals

One lobster clasp

A pair of earring wires

Nymo thread, size D, in a complementary colour

Size 10 beading needle

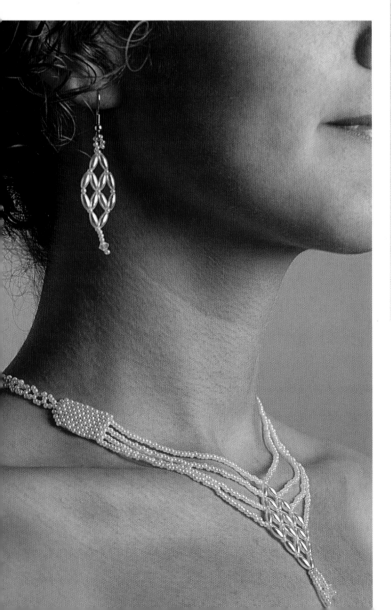

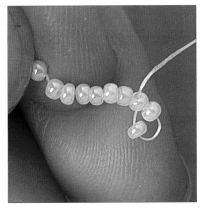

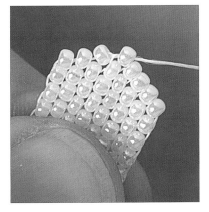

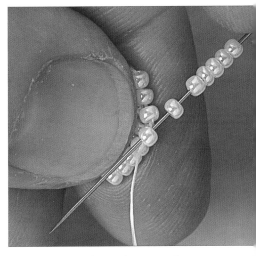

1. Starting with the Japanese seed beads, attach a white stopper bead approximately 15cm (6in) from the end of the thread. Pick up eight beads for the first two rows of peyote stitch. Begin the third row by picking up another bead and passing the thread through the second bead along in the first row.

2. Work twenty rows in peyote stitch following the method on pages 25–27, then decrease to a point (see pages 27–28).

3. Begin the right-angle weave (see pages 35–37). Pick up six beads, take the thread round and pass the needle through the bead the thread is coming out from.

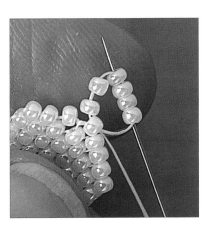

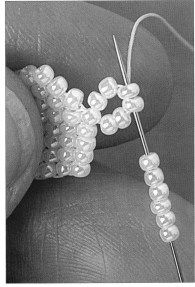

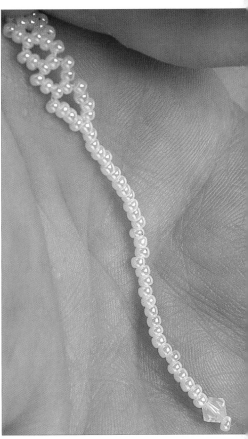

4. Pull the thread tight to form a loop and go back through the first four beads you added.

5. Pick up six more beads, and take the needle round and back through the third and fourth beads of the previous round.

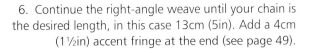

6. Continue the right-angle weave until your chain is the desired length, in this case 13cm (5in). Add a 4cm (1½in) accent fringe at the end (see page 49).

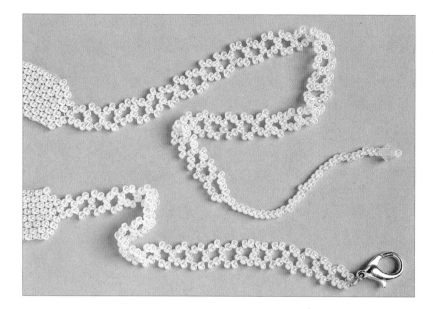

7. Repeat steps 1–6 to create the other side of the necklace, but this time attach a lobster clasp to the end of the right-angle weave instead of a fringe.

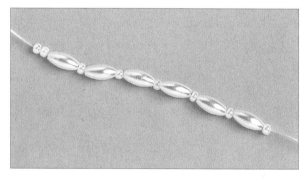

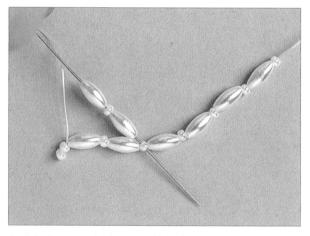

8. To begin the centre motif, pick up one seed bead and go through it again to create a stopper bead. Pick up a rice bead then alternate seed and rice beads until you have six rice beads and seven seed beads on the thread. Now pick up another seed bead.

9. Missing out the last seed bead added, go through the next seed bead along. Pick up one rice bead, one seed bead and one rice bead and pass the needle through the fourth seed bead in the first row.

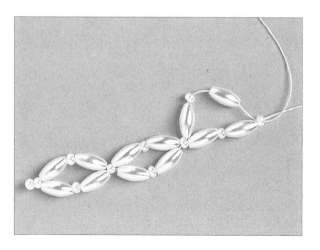

10. Pick up one rice, one seed and one rice bead and go through the sixth seed bead in the previous row. Repeat, and go through the stopper bead.

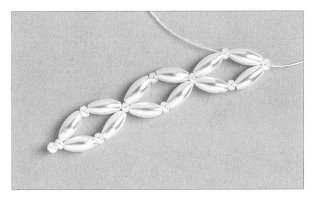

11. To begin the next row, pass the thread through the first rice bead and the following seed bead in the row before.

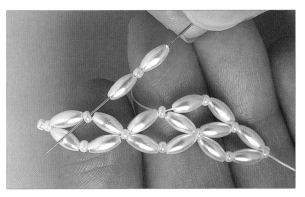

12. Make two further three-bead loops as you did in the previous row.

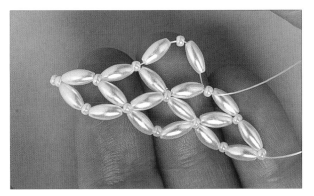

13. Create a triangular shape by making another three-bead loop working back in the other direction. This completes one half of the central design.

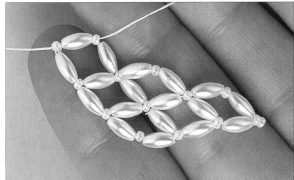

14. To make the other half, weave the thread through to the seed bead at the end of the first row. Take it through this bead, then through the next rice bead and seed bead of the first row.

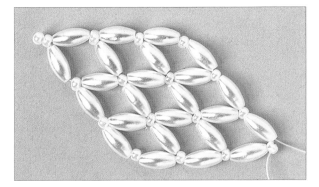

15. Complete the central design, finally weaving the thread through to the end of the first row.

16. Join three simple fringes to the stopper bead at the tip of the central design.

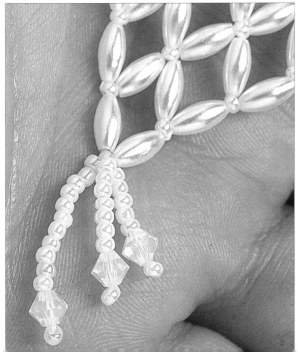

17. Use four simple strings of seed beads to attach the central design to each block of peyote stitch. Start by weaving through the peyote-stitch block, emerging through one of the end beads in the first row. Add approximately fifty beads, then take the needle through the appropriate seed bead on the edge of the central design. Re-weave the thread back through all the beads on the string to strengthen it, and repeat for each string.

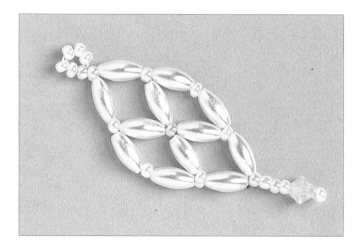

Tip
Make sure facing strings are the same length to achieve a balanced finish.

18. Make each earring in the same way as the central design, starting with four rice beads instead of six. Attach a small loop of beads at one end and a short accent fringe at the other.

19. Prize open the end of the earring wire using a pair of pliers.

20. Loop on the earring and close the wire.

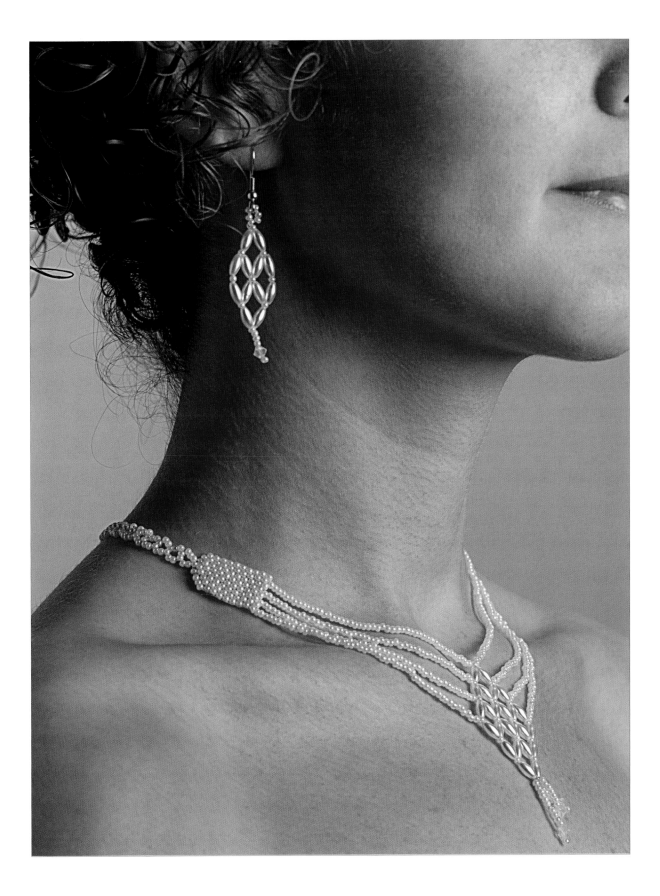

Index

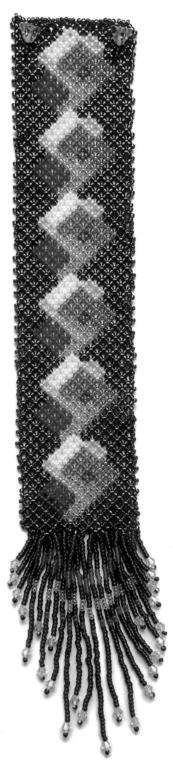

*This beaded cuff is made following the pattern on
page 61 but using different-coloured beads.*